THE BAUHAUS IDEAL THEN & NOW

THE BAUHAUS IDEAL THEN & NOW

An Illustrated Guide to Modern Design

WILLIAM SMOCK

Academy Chicago Publishers

Published in 2004 by Academy Chicago Publishers
An imprint of Chicago Review Press Incorporated
814 North Franklin Street
Chicago, Illinois 60610
ISBN 978-0-89733-590-4

Library of Congress Cataloging-in-Publication Data are on file with the publisher.

All illustrations are by William Smock with the following exceptions:
Page 12: Catalogue page from *Isamu Noguchi · Rosanjin Kitaoji*, Osaka, Yomiuri Shim-bun, 1996, page 169. Photos by Kevin Noble courtesy of the Isamu Noguchi Foundation. Used by permission.
Page 42: Graphic design example ©2003 Grace Sullivan. Used by permission.
Page 65: Symbols from Schiphol Airport, Amsterdam
Page 78: Olympic sports palace, Rome, 1960. Figure 131 from *Aesthetics and Technology in Building* by Pier Luigi Nervi, Cambridge, Harvard University Press, 1965. Used by permission.
Page 91: Chart copyrighted by the estate of Henry Dreyfuss, used by permission. Reprinted from *Henry Dreyfuss, Industrial Designer: The Man in the Brown Suit* by Russell Flinchum.
Page 98, bottom: "Contemporary City for 3,000,000 Inhabitants" by Le Corbusier, 1922. ©2003 Artists Rights Society (ARS), New York/ ADAGP, Paris/ Fondation Le Corbusier. Used by permission.
Page 100: Top silhouette of Chandigarh by Le Corbusier, 1950–1965. ©2003 Artists Rights Society (ARS), New York/ ADAGP, Paris/ Fondation Le Corbusier. Used by permission.

Printed and bound in the United States of America

Part I. What Did the Bauhaus Stand For?

Part II. Was the Bauhaus Right?

Part III. Is There Life In the Bauhaus Ideal?

Introduction

WHAT DISTINGUISHES GOOD design from bad?

What pool of ideas and examples do architects and industrial designers draw on?

In 1960 these questions would have been easier to answer. Design was still a magic word, and the modern movement associated with the Bauhaus was reshaping the world. Its challenge to architects and designers showed no signs of flagging. Modernism offered clear, serviceable design principles.

But few would claim to be modernists now, especially the architects and designers who enlisted in the modernist cause as students. Postmodern design rejects principles. It is about desire, ambiguity, and chance. This is the Information Age, not the Great Society.

The Bauhaus was a product of its own time and place—Germany between two world wars. Long after its internal conflicts were forgotten, however, it came to epitomize the promise of design. Most modern design ideas predate the Bauhaus— sans serif type, skeletal furniture, flat roofs—but the Bauhaus wrapped them up in a compelling package. The Bauhaus stood for design in the public interest, for economy, simplicity and usefulness. It told us what we ought to like.

Designers and architects around the world were inspired by the Bauhaus example. Then they reacted against it. At each stage, Bauhaus ideas about human nature, about social responsibility and taste provided the stimulus.

Modern design aimed to create meaningful order, to fit our physical surroundings to our needs and aspirations. This idea will never go out of date. Who doesn't feel a sneaking affection for Buckminster Fuller? Scolds like Donald Norman and Victor Papanek, insisting that their brand of design could revolutionize everyday life, always find an appreciative audience. Andres Duany, whose New Urbanist recipe promises to turn subdivisions into hometowns, is greeted everywhere as a Messiah. Though moralizing may be out of style, there is no pleasure like knowing best.

Warning against design moralism, Rem Koolhaas studies shopping patterns and designs expensive stores. He praises the imaginative spillover that produced Manhattan. It's true that no rational designer could have dreamed up New York. But New York is not my dream city. Neither is Berkeley, California, where I live. I

can't help feeling there is room for improvement. A lot of the best things in New York—parks, subways, museums—came from sober design foresight.

In the prosperous period following World War II, Bauhaus-inspired modernists threw themselves into physical and social engineering. But public housing, mass transit and urban renewal did not erase big city problems. We live in a cynical time when taxpayers refuse to pay for public works, when the consumer is king and the mall is his library, church and hobby center rolled into one. What is the designer's mandate now?

An answer came from Frank Gehry, Philippe Starck and Ettore Sottsass in the 1970s: design will be personal and idiosyncratic. It can be grandiose. It can be superficial. It should not be boring as modernism often was.

But very few practicing designers get a chance to show off. Most have to find a middle ground between originality and salability. This dissonance between the dream and the reality is nothing new. Design has always been a back-and-forth series of accommodations between the creative impulse and the marketplace. Bauhaus visionaries hoped that, by embracing economic constraints, they could magnify the designer's role. Their plain, sensible ideas staved off the pruning impulses of the cost cutters.

I was born in the hopeful era following World War II. I learned that design was going to transform everyday life for the better. My hometown replaced a dark old Gothic high school with a new one that had big picture windows and colorful plastic chairs. I learned that art is hard to understand, and have been trying to understand Ingmar Bergman, James Joyce and Jackson Pollock ever since. Modernists believed that scientific and technical advances produced a break in history: the twentieth century was a radically new era with little to learn from the past. Modernism focused on the infinite promise of the future. That kind of confidence is no longer in the air, and I miss it.

Having visited the Vitra Museum near Basel, where modern design is sold as a luxury item, I take grateful refuge in the Bauhaus ideal. I can't afford what Vitra sells, not even the cheapest things—$100 model chairs whose function has been neatly subtracted. Vitra wants you to think of "good design" as something like Beluga caviar, blessed with an aura of quality, desirable mostly because it costs a lot.

Taste in design does not evolve at a steady pace across the board. Architects, whose style cycles last for decades, haven't forgotten modernism yet. Fashion designers, who change every season, forgot it twenty-five years ago. Graphic designers gave up Helvetica and the grid, came back, and have now progressed well into the fusion stage. In this book I talk only about the slowest workers— the three-dimensional designers, whose output is all around us and built to last.

The first section, aimed at people under forty-five, tells what modern design is.

The second part contrasts the promise of modernism with its actual results. A lot of modern design, aiming for timelessness, now looks dated. Picking through the Jetsons' attic, I try to separate creative design strategies from herd behavior. This quick, hypercritical shopping trip through twentieth-century design history was fun. With the benefit of hindsight, it's easy to put modernism to the acid test.

The third part of the book suggests how designers can build on modernism without indulging in retro nostalgia. I propose a marriage between the best postmodern character traits—irony, critical self-awareness, modesty—and the best modernist ones—honesty, generosity, and reasonableness.

No one wants to drag design back to 1960. But fifty years of modernist experimentation must hold some lessons for the future. I can't imagine a design curriculum which doesn't stress problem-solving. School is a rational way of transmitting skills and knowledge; modernists wrote the book on rational design.

I have a special attachment to the modern because of its do-gooding bent. Postmodern doesn't have this bent. Frank Gehry couldn't care less about low-cost housing, and Philippe Starck is not very likely to work on school furniture.

I am neither an expert nor a scholar. Design is for everybody. I try to present visible corroboration of what I say. Most of my examples should look familiar.

Design is one of the glories of civilization. At this very moment you are probably sitting in a chair somebody designed, in a room somebody designed, surrounded by (and wearing) designed things. Photographers like Eugene Atget and Walker Evans, who let people's rooms and settings speak for them, can be seen as design historians. I want to encourage readers to draw their own conclusions, to sharpen their eyes and minds on the evidence all around them. As consumers, they have the deciding vote.

I owe a lot to designer Bruce Burdick. Most of the research for this book was done while I was working on his projects. He encouraged me to think about the hardest design questions and tax my imagination to the utmost. I am grateful to many readers. The most meticulous and helpful one was Marc Treib. Jay Adams and Jane Cee have been my windows on the profession of architecture. Richard Serrano supplied invaluable reference materials. Some of my best ideas are actually the ideas of Steve Tornallyay.

A note on terminology: I use "postmodern" in the broadest possible sense—to cover everyone who, starting in the late 1960s, set out to overthrow modernism. Not all of them welcome the label because it also has a philosophical connotation, introduced by Jean-François Lyotard, dealing with the French-influenced world of literary theory and philosophy. For my purposes, "postmodern" simply means the design movement that followed the modern.

Introduction to the Second Edition

SINCE I WROTE THIS slender book my horizons have widened a little. I have already praised Ikea for making handsome, useful things available at reasonable cost. I would like to add another company that delivers on the Bauhaus ideal: Oxo. When I first saw Oxo kitchen tools I assumed they were expensive because they work better and look better than the competition. They aren't more expensive.

I have visited two signal achievements of postmodern architecture: Frank Gehry's Disney Concert Hall in Los Angeles, and Jean Nouvel's Tyrone Guthrie Theater in Minneapolis. They gave me more respect for architects who defy Bauhaus precedents.

The Disney Concert Hall is not a sensible building. There was no reason to wrap it in stainless steel sails, to make the walls curve or the verticals slant. The one logical element is the all-wood auditorium, which resonates like a violin.

Gehry conceived it as a luxury item and insisted that the donor, Walt Disney's widow, pay for it. Construction was delayed for years by ballooning costs. But the result is worth it—a beautifully crafted curiosity, something only a monarch could afford, like a French chateau or a Fabergé egg.

There are unforeseen bonuses like the walkway around the building, hidden behind stainless steel sails, offering views across the city.

This is the main lobby, four stories tall. Departing altogether from a perpendicular grid, architects had to harmonize big curves and sharp angles in three dimensions.

They succeeded. To my amazement, all those errant edges meet in a satisfying way. The curving ramps relate to the jutting balconies, the plaster surfaces complement wood–faced columns and painted steel

structural elements, the light gets through the stainless steel facade in a way that flatters these sculptural forms.

Jean Nouvel's Minneapolis theater is not so obviously expensive, but it is almost as splashy, a cluster of theaters in shiny blue housings, topped by stylized smokestacks. What makes it successful is its fit with the setting. It stands above waterfalls of the Mississipi River that once supplied water power to flour mills. There is a power plant across the river and the horizon is ringed by huge concrete silos. Any form punier than a silo or a power plant would look silly here. Nouvel further defers to the setting by projecting a ledge out towards the river, big enough to hold an entire theater lobby, offering panoramic views.

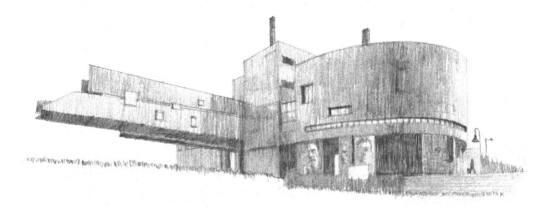

Both Gehry and Jean Nouvel built showy landmarks. Modernist architects, by contrast, disapproved of show. Have Gehry and Nouvel proved the Bauhaus wrong? I don't think so. Gehry and Nouvel are not necessarily thumbing their noses at functionalism. They are making something different, one-of-a-kind structures that would be terrible as schools or factories or apartment houses.

We are all designers—laying out web pages and Powerpoint presentations, gardens and dinner tables, offices and dormitory rooms. I hope this book, exploring why we like what we like, makes the process less mysterious and more satisfying.

William Smock
Berkeley
February 2009

Part I
What Did the Bauhaus Stand For?

What Was the Bauhaus?

The Bauhaus was a design school which opened in Germany after World War I. The name means "house of building." Its founder, architect Walter Gropius, wanted a complete break with the past, both in design and in education. He hired gifted teachers who in turn recruited their best students to teach.

The goal was to replace Victorian-era design with a plain style suited to the machine age. Bauhaus initiatives grew into a movement which brought us white interiors, sling chairs and glass skyscrapers. The movement had other parents—the French architect Le Corbusier, for one. But the Bauhaus makes a good beginning because it itself was the product of a new, ambitious design—what I'm calling the "Bauhaus ideal." Bauhaus teachers, their common purpose and methods, will serve as a starting point for the histories traced out in this book.

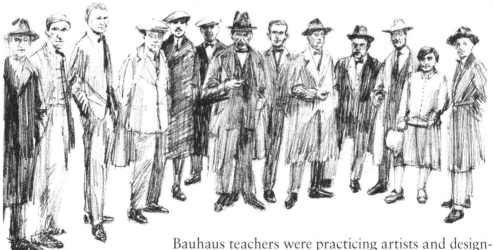

Bauhaus teachers were practicing artists and designers. After the Bauhaus closed in 1933, many of its teachers became influential in America. New York's Museum of Modern Art has work by all the following Bauhaus teachers:

Anni Albers—textile designer. Studied and later taught weaving at the Bauhaus. Then went with her husband Josef Albers to Black Mountain College in North Carolina, where they taught for sixteen years.

Her textile designs recall the paintings of her teacher, Paul Klee. She had a one-woman show at The Museum of Modern Art.

Josef Albers—painter. Best known for the series of color studies called "Homage to the Square."

A student who became a teacher at the Bauhaus, he taught after 1933 at Black Mountain College. His associates there

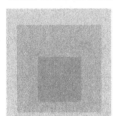

included John Cage, Merce Cunningham, Robert Rauschenberg and Buckminster Fuller. He ended his career as head of the Yale Design Department.

Laszlo Moholy-Nagy—photographer, designer and sculptor. Known for his abstract sculptures in unconventional materials—metal, plastic, wire. He is also celebrated for photographs and photocollages that flatten space into dynamic two-dimensional compositions. After teaching at the Bauhaus, he founded a successor institution, the New Bauhaus, in Chicago. It later merged with the Illinois Institute of Technology.

Herbert Bayer—graphic designer. Studied painting at the Bauhaus, then founded its printing and advertising workshop. Responsible for the sans-serif type face he called "Universal." From 1938 he worked as a graphic designer in New York. Notable projects include a series of artist-illustrated ads for Container Corporation of America, "Great Ideas of Western Man."

Marcel Breuer—designer and architect. Student at the Bauhaus, then a teacher. Several of the chairs he designed there are still in great demand. Became an architect in America; his buildings include the Whitney Museum and UNESCO headquarters in Paris.

Ludwig Mies van der Rohe—architect. His buildings are celebrated as the purest and most elegant achievements of modern design. After heading the Bauhaus from 1930 to 1933, he moved to Chicago, where he built a new campus for the Illinois Institute of Technology. His skyscrapers in Chicago and New York and public buildings in Berlin are all variations on the glass box. The Museum of Modern Art has his collected papers.

Paul Klee—artist. Although his friends were expressionists, his own work is quiet and small—dream imagery quickly rendered by a skilled hand. He tried to respond spontaneously—like a child—to the blank white page. This distrust of technique made him an unlikely teacher. He believed that line and color have inherent communicative properties, and that is what he taught.

Wassily Kandinsky—painter. Born in Russia, he went to Germany to join the avant garde. Like Klee, he believed that color and form send messages independent of the physical things they represent. To explore this language, he invented abstract painting. His paintings form the core of the Solomon Guggenheim collection in New York.

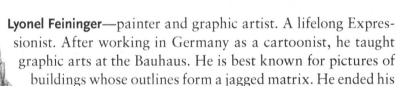

Walter Gropius—architect. He founded the Bauhaus to bring craftspeople and artists together, breaking down professional barriers. A moving force in the International Style of architecture, he came to the U.S. in 1938 to teach at Harvard. He became head of the Graduate School of Design and founded a Cambridge architecture firm, The Architects Collaborative.

Lyonel Feininger—painter and graphic artist. A lifelong Expressionist. After working in Germany as a cartoonist, he taught graphic arts at the Bauhaus. He is best known for pictures of buildings whose outlines form a jagged matrix. He ended his career in New York, where the Museum of Modern Art held a retrospective of his work in 1944.

Gunta Stöltzl—textile designer. Headed the Bauhaus weaving workshop. Her designs and abstract tapestries were as influential in Europe as Anni Albers' patterns were in America.

Johannes Itten—painter and theorist. He devised the beginning course at the Bauhaus where students learned to handle colors, forms and materials. Some of his ideas about visual order and harmony come from Mazdaznan, a contemporary religion based on Persian Zoroastrianism. He left the Bauhaus when its emphasis shifted to industrial production, but continued to teach and write for the rest of his life. His books on color and form are still in print.

Marianne Brandt—designer. Her Bauhaus teapots and silver services, with their simple geometric profiles, are now prized collectors' items. The silver was never mass-produced, but her metal reading lamps were a great commercial success.

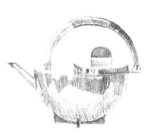

Oskar Schlemmer—taught mural painting, sculpture, and theater. Best-known for Bauhaus theater pieces in which the students padded themselves out as schematized human forms to perform dance/pantomimes. Although he was an inspiring teacher, his concepts did not survive as part of the Bauhaus design legacy.

Instead of simply being horrified by it, Bauhaus designers wanted to master the industrializing trend that produced factory towns like Pittsburgh and Manchester and the lethal technologies of World War I. They wanted to make work meaningful, products beautiful, and everyday life healthy and invigorating. They were very conscious of being in the avant garde.

Their work and ideas form the basis for modern design. Rather than giving a detailed account of the Bauhaus, I will start by showing why the Bauhaus still matters: the persistence of Bauhaus ideas all around us.

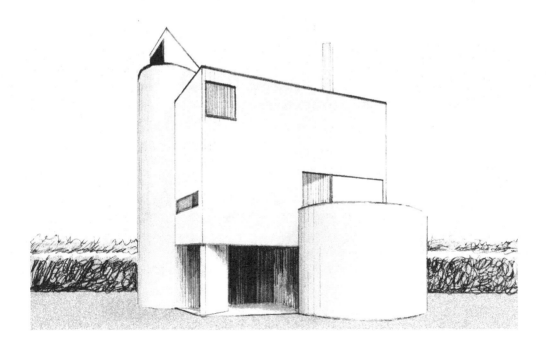

What Is the Bauhaus Legacy—Modern Design?

The heyday of modern design in America was the 1940s through the 1970s. Although modernism—spare, cool, and geometrical—was equally influential in print, product and interior design, its principles were best stated by architects.

a. For example, "form follows function"

This design commandment, first pronounced in the nineteenth century, was carried to a logical extreme by Mies van der Rohe. His glass skyscrapers bear no author's signature, no beautifying touches. They just do what they do, which is to house offices or apartments. "Clean" and "honest" are words of praise that Mies helped add to the vocabulary of architectural criticism.

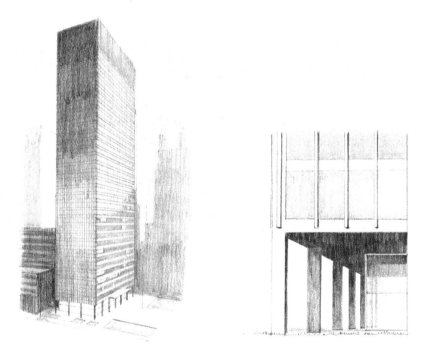

This New York skyscraper, the Seagram Building (1958), is held up by a frame of steel beams, not by its walls. A transparent ground floor dramatizes this. Mies practiced design from the inside out, welcoming engineering advances because they suggested new structural opportunities.

Before "form follows function," designers looked to the past for forms they could borrow. But after this precept became popular, products and buildings stopped trying to look like something else. Material and surface treatment were limited to a bare minimum. The mechanics were allowed to show. Form and content became identical.

b. A corollary principle is "truth to materials"

Let each material be itself—no plastic disguised as wood, chrome, fabric or leather. No particleboard masquerading as oak. No gold tone metal, embossed linoleum, flocked wallpaper. Like a cloud or a peach, the plain truth has the beauty of sheer simplicity.

Real, not fake. Bring out the beauty in the thing itself.

Modernists rejected symbolism—housing county courthouses in Greek temples, for example—as a design strategy. After all, Greek temples were functional in their time. Stone columns supported a rectangle of stone slabs. The columns are spaced at intervals a convenient-sized slab can bridge. A tiled wooden roof rests across the top.

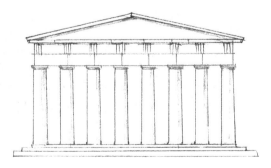

A Roman aqueduct uses blocks and mortar to step up stone's structural possibilities.

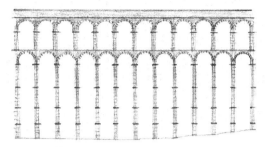

A barn is a functional wood structure. A circular hut is a functional mud structure. In the same way, the Seagram building was considered by modernists to be a sensible way to build with steel and glass.

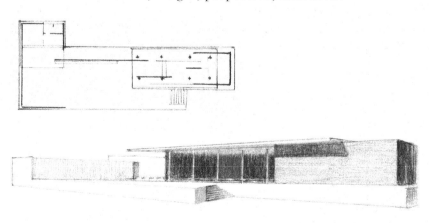

c. Mies van der Rohe had another commandment: "less is more."

This idea is linked to the preceding ones. Mies took an engineering principle—economy—and made it an aesthetic principle. In engineering, "economical" means cost-efficient. To Mies it meant visually efficient. Good design, he believed, shows how a building works. Strip off ornament, symbolism, gesture. What's left is the bare bones: texture and color, weight, proportion, silhouette.

Mies's 1929 Barcelona Pavilion is a building reduced to the bare minimum—a top, a bottom, and some sides.

Mies's reductive strategy works with most design problems. He did a chair for the Barcelona Pavilion. It uses no more material than comfort requires.

Shiny metal ribbons form the frame. Cloth straps bridge the seat and back. Thin leather cushions distribute your weight.

Graphic designers applied the same principle of economy to ancient Roman letters, in the belief that the minimal solution is the best-looking, too. Clean and uncluttered, straightforward, unapologetic.

Modernist graphic design stressed clarity and order. In addition to using stripped-down type faces, designers laid out pages on a rectangular grid.

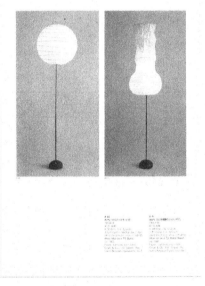

Product designers, too, embraced the idea that less is more.

Forty-five-pound canvas tents gave way to nylon domes.

Rejecting the antique as a source of ideas, modern designers looked for inspiration to non-Western cultures, and in places where work is done—workshops, laboratories and kitchens.

What Came Before?

Before Mies and his contemporaries, buildings justified their existence in symbolic terms. American universities built campuses that looked like English universities. They glued Gothic façades on hulking gyms and power plants. Even skyscrapers got the Gothic treatment, aeries of steel pretending to be stone piles. The Empire State Building, for decades the world's tallest building, is faced in stone.

Other ways a veneer of meaning was pasted onto buildings at the expense of what modernists would consider engineering candor:

French chateaux were blown up to a fantastic scale.

Half-timbered Tudor structures, frameworks of squared tree trunks filled in with mortar and rubble, are mimicked by tall apartment houses, storefronts and bungalows.

The whitewashed adobe of the Spanish mission architecture reappears in California bungalows, train stations and city halls.

The Greek temple, an open-air pavilion built to house statues of the gods, grew and grew, into courthouses and post offices and finally into structures as huge as the U.S. Department of Agriculture and the Metropolitan Museum of Art.

This turn-of-the-century Carpenter Gothic house does everything it can to exalt its scale, its purpose, and its relatively cheap construction. My parents used to call nailed-on wooden detail "gingerbread." We had a Colonial house. Tastes have now come full circle, and I live in a house like this one.

In industrial design, the nightmare haunting modernists was the late nineteenth-century parlor—dark, heavy, and cluttered.

Rather than diffuse the light, lampshades simply blocked it.

Armchairs were overstuffed, though not necessarily comfortable.

Pattern splashed across furniture, walls and floors does nothing but camouflage their function.

How Did Modern Design Change the World?

Handmade things yielded pride of place to machine-made things. "Good" and "fancy" were no longer synonymous. Stainless steel flatware replaced heirloom silver.

Lamps came to look like streetlights, not like vases. Goodbye to cut glass, lace, and heavy drapes on windows. Goodbye to mahogany dining room furniture and glass-fronted cabinets full of heirloom china.

Cars stopped mimicking carriages and started trying to look like airplanes. Things with soft, anatomical associations were redefined in hard-edged ways. Le Corbusier called the house a "machine for living." Food and clothing that came readymade from a factory began to look more appealing than the handmade variety.

Modernism is optimistic. New is always better. Good design puts technical advances to work. Tabletop devices became handheld. Radios, adding machines, gramophones and telephones eventually shrank to pocket size. Machines eliminated some boring, repetitive work—dishwashing, retyping, hanging out the clothes . . . We confidently expected further improvements to arrive at an ever-accelerating rate.

Modernism is an appeal to reason, like the Declaration of Independence. In the eighteenth century Americans declared that government derives from popular consent. Then the French Revolution swept out religion and class privilege. It tore down prisons, knocked the noses off the saints' statues, guillotined the king and restarted the year count at 1. Though it is best remembered for its excesses, this effort to put everything on a logical footing was part of a trend called the Enlightenment that continues to this day.

I don't think it's a coincidence that Mies van der Rohe's hypersensible buildings are full of light. The modernists, promising to deliver daylight and fresh air, took nature and the common good as guiding principles, not the glory of God or the authority of the state. Treating a building as a machine, not a nest of symbols, was a rational move. And letting advances in engineering, not custom, dictate a building's form was looked upon by modernists as a tribute to human reason.

In addition, "less is more" is an internationalist, transcultural ideal. By subtracting history from design and replacing it with timeless universal principles, modernism was intended to create forms that spoke to everyone. This dream actually came true. Finnish and Japanese architects made landmark American buildings, and vice versa. Danish furniture sold here. Japanese stuff sold everywhere. Both the Nazis and later the East German Communists condemned the Bauhaus's failure to mirror Germany's "national character."

"Less is more" also had a democratic, egalitarian side. Modernist pioneers like Walter Gropius resisted monumentality in architecture. Gropius inscribed human dimensions (in most cases, the height of each floor) on the outside of the Bauhaus building. "Human scale" affirmed that buildings were machines for people's use, not billboards for state or religious power.

Adolph Hitler preferred a grandiose neoclassical style. His chief architect, Albert Speer, designed public spaces and buildings that wrapped the authority of the state in a huge, intimidating package.

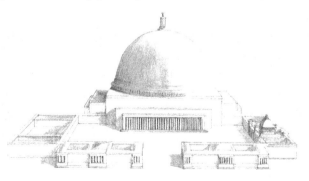

What Does Modern Art Have to Do With It?

The Bauhaus was born when Walter Gropius took charge of an art school in Weimar. After Germany's defeat in World War I, power in that province passed from a Grand Duke to an elected parliament. Like Gropius, the parliament wanted Germany to head in a new direction. Gropius began by merging the provincial art school with the school of arts and crafts, abolishing the distinction between pure and applied art.

Bau means "building." Gropius declared in the new school's catalogue that building unifies all arts and crafts. With this common goal they could be taught under one roof.

The faculty was divided between "masters of form" (artists) and "masters of technique" (craftsmen). They taught side-by-side in workshops devoted to a particular material: wood, metal, glass. In addition to working at drafting tables, students had to qualify as journeymen in a trade.

Half the entering class were women, though most of them gravitated toward feminine specialties such as weaving.

Before choosing a craft, students spent a year learning the principles of design—the elements that correspond to words and grammar in language.

Gropius hired avant garde artists to teach this course, including Klee and Kandinsky.

Sculpture and mural painting, art forms subordinate to "building," had their own workshops at the Bauhaus. But easel painting did not. Gropius denounced "art for art's sake" as sterile self-indulgence. The Russian Revolution was only a year old. Russian artists like El Lissitsky and Alexander Rodchenko had gone to work designing posters and advertisements. They wanted art to serve the people, not wealthy connoisseurs.

Criticizing art schools, Gropius wrote in 1923, "The fundamental pedagogic mistake of the academy arose from its preoccupation with the idea of the individual genius and its discounting of the value of commendable achievement on a less exalted level. Since the academy trained a myriad of minor talents in drawing and painting, of whom scarcely one in a thousand became a genuine architect or painter, the great mass of these individuals, fed upon false hopes and trained as one-sided academicians, was condemned to a life of fruitless artistic activity."[1]

It's not that Walter Gropius despised modern art. His teaching staff—Klee and Kandinsky in particular— helped define it. Bauhaus stage experiments influenced modern dance and theater. But he didn't think it could be taught. Aside from a shared spirit of adventure, Bauhaus design had little to do with "high" art.

In *The Demoiselles of Avignon* (1907), Picasso bent over backward not to communicate a thought or report an experience. The image cannot be summed up or explained, least of all by Picasso. It is not craftsmanlike. And it has no redeeming social value. With a few exceptions, such as *Guernica*, Picasso's painting is art for art's sake.

Modern artists obeyed mysterious inner promptings. They didn't teach you, raise your morale, or tell you a story. Modern art exists for its own sake. It does, however, share the Bauhaus ideal of paring things to the bone.

Modern dance evolved in New York in the '30s. Martha Graham was one of the pioneers. She discarded ballet conventions—toe shoes, tutus, and painted backdrops. She danced on a bare stage in bare feet. Her sketchy plot lines and sparse sets dramatized psychological lines of force.

Modern novelists stopped writing fictionalized history. James Joyce, William Faulkner, Virginia Woolf and Samuel Beckett purposely mixed up objective

[1] Herbert Bayer, Walter Gropius and Ise Gropius, editors, *Bauhaus 1919–1928*. New York: Museum of Modern Art, 1938 (an exhibition catalogue). This quotation is from an essay published by the Bauhaus called "The Theory and Organization of the Bauhaus."

description with their characters' imaginings. They wrote books that stress idiosyncratic word choices and breakdowns in narrative logic. They call attention to their form, which is, in each case, newly minted.

Modern music is hard to whistle. You know it's modern when the audience riots. The premiere of Stravinsky's *Rite of Spring* in 1913 is a case in point. Arnold Schoenberg's twelve-tone system dispensed with melody, historical context, authorial voice. High modernist John Cage wrote a piano work whose "player" just sits silently for twenty minutes.

The Modern Jazz Quartet, which flourished in the 1960s, wore tailored suits and steered clear of the wild, spontaneous side of jazz. Their music was sophisticated and cool—not an explosion of raw feeling but an elegant formal exercise, like the music of J.S. Bach.

In sum, modern art was formalist, stressing form as a value independent of communication. A novel was no longer a good yarn. A concerto did not move anyone to tears. A painting no longer recreated a moment in the past. A dance did not reinforce noble ideals of love and honor. Modern artists shared with modern designers an urge to sweep out nineteenth century romanticism—considered by modernists to be ornate, sentimental, and fake.

Just for the record, modern art has plenty of nineteenth-century ties. Its forefathers are nineteenth-century figures: Van Gogh, Mallarmé, Nietzsche, Marx, Walt Whitman and Herman Melville. Abstract expressionists thought they were erasing art history. But T.J. Clark points out (affectionately) that their exalted faith in individual expression, their wealthy patrons, their agitated forms and portentous utterances all hearken back to the preceding century.[2]

Modern artists despised the bourgeoisie—uncultured boobs who don't know much about art but know what they like. To modernists, popular, profitable art was by definition dishonest, because it was crafted to sell. To them, Hollywood movies, with quirky exceptions like Bogart and the Marx Brothers, were crap. So were best-selling books.

[2] T.J. Clark, *Farewell to an Idea: Episodes from a History of Modernism.* Chapter 7: "In Defense of Abstract Expressionism." New Haven: Yale University Press, 1999.

Putting it another way, modernism was elitist. Not in an aristocratic way—Picasso, for example, belonged to the Communist Party. But modernists—both artists and designers—did nudge people to raise their sights. Our current faith in the marketplace, our reliance on the profit motive to shape our culture, is utterly at odds with the modernist constellation of beliefs. Ronald Reagan—B-movie star, babbler of clichés, focused on an epic past that only exists in the movies—could be seen as modernism's precise opposite.

Art's turn toward radical individuality cut away the common ground between art and architecture. "Art," says sculptor Claes Oldenburg, "does not have windows or toilets."[3] It is produced in garrets for the personal satisfaction of the artist. Buildings have to please wealthy clients. And highly original buildings, which take extra effort and expense, ask even more of the client.

The split between art, on the one hand, and crafts, design, and illustration on the other, was painful for the non-artists. In certain crafts it has become a point of pride to make useless things (in other words, art)—garments that can't be worn, bookshelves too small for books, teapots with holes in them.

Before modernism, architects had been paid to create buildings with beguiling surfaces. Like the painters and sculptors of the time, they made learned allusions to the past. Long façades were broken up by columns, pediments, porches and indentations. The roof line was varied with railings, finials, and sculpture. Schools and libraries had stern heroic figures marching around the outside and wise maxims above the door.

[3] "Art and Architecture, Dueling on a Very High Plain," *New York Times*, April 29, 1998, p. B1.

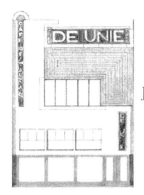

There have been buildings that look like modern art. J.J.P. Oud's 1925 Café de Unie looks like a Mondrian.

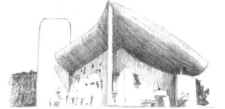

Le Corbusier's 1955 chapel at Ronchamp looks like a sculpture.

Eero Saarinen's 1956 TWA terminal at JFK airport looks like a fallen blossom or a huddle of crabs—there aren't any right angles.

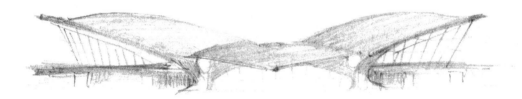

The Sydney Opera House (conceived in 1957) is equally sculptural. Its architect, Jørn Utzon, may also have had nature in mind. The "sail" forms are like petals or teeth.

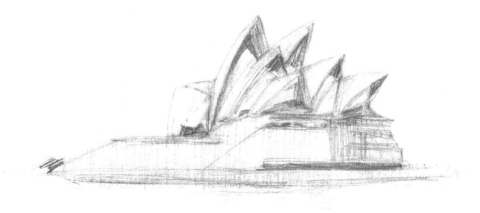

Most modern architecture, however, is straight and rectilinear rather than grandiloquent and curvaceous. Rather than turn out "debased" commercial art, architects chose to become tasteful and imaginative engineers. Architects could not make Picassos. But like Picasso, they turned away from representation.

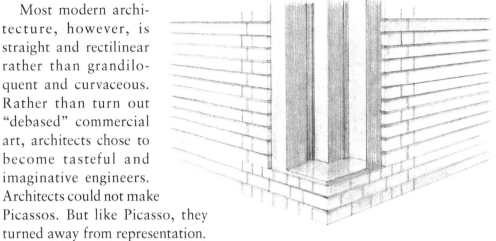

They stopped building Greek temples, Spanish missions and Georgian country houses. They made forthright boxes.

Leading architects declared that factories—designed by engineers with no aesthetic agenda—were the perfect model. Steel mills and auto plants were steel-framed boxes with "curtain walls"—thin, inexpensive sheathing—of glass, masonry or sheet metal. Little was done to vary or beautify their appearance.

Architects used the rhythm of window openings and the texture of the building materials to jazz up blank façades. Function provided a new formal vocabulary. Once the evening clothes are taken off a building, we are left with a naked volume, the structural bones, the weatherproof skin, and openings for light, air and access. These elements don't have to be flat, symmetrical, or gray.

They can be handled in a very dynamic way. "Less is more" gave Mies and his peers an avant garde posture of their own.

To counteract the mechanical character of their buildings, and to renew their kinship with artists, architects commissioned modern sculpture—up-to-date replacements for the general on horseback.

UNESCO, for example commissioned Henry Moore, Joan Miro, Picasso and Alexander Calder to make large outdoor works for its Paris headquarters. The results are just weatherproofed, out-of-scale refugees from an art gallery. Aside from Picasso's *Guernica*, modern art doesn't have any civic meaning. That may be why people have responded so deliriously to another rare exception to this rule, Maya Lin's Vietnam Memorial.

Sculptor Isamu Noguchi was asked to represent Asia at UNESCO. He filled an empty courtyard with a modernist garden, a "sculpture" with social tentacles.

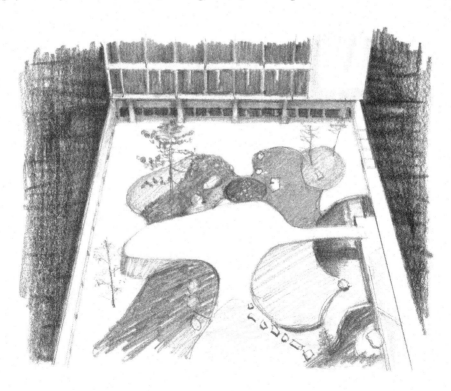

By contrast, when architects asked Picasso for a sculpture, he would send a little handmade maquette, to be blown up to any size the architect required. The silliest example is at I.M. Pei's Silver Towers in Greenwich Village, where a six-inch scrap of painted tin was translated into a 38-foot concrete slab.

It's not that art and design are unrelated. They are still strongly identified in people's minds. For example, people like to attribute a building to a single author, not to a firm (the corps of architects who work together on the job).

Some firms resist this fiction. Walter Gropius called his firm The Architects Collaborative. But it is pretty much a business necessity for architects like I.M. Pei to pretend that they personally design dozens of buildings around the world every year. In reality, big name architects spend a lot of time with clients, working to counteract the impression that anonymous underlings do the work.

Pei is in charge. The buildings he signs are his work. But not in the same way a painting would be.

When Did Modern Design Stop Looking New?

A good place to see how modernism failed to live up to its billing is the Museum of Modern Art in New York. In 1929, when a consortium of millionaires led by Mrs. John D. Rockefeller, Jr., founded it, the MoMA represented itself as the up-to-date alternative to the big old Metropolitan Museum, with its Dutch masters and suits of medieval armor. To keep its collection modern, the new museum would kick out artists on the fiftieth anniversary of their deaths, sending their work up to the Metropolitan Museum.

In the '30s, MoMA curators worked to articulate a comprehensive modernist program that embraced architecture, film, photography and design as well as painting and sculpture.

A 1932 exhibit called "The International Style" elevated the modern architecture of Le Corbusier, Mies, Walter Gropius and others into an official canon. The museum commissioned architects to build model houses in its courtyard.

In 1938, the Museum had a big exhibition on the Bauhaus, illustrating every aspect of its teaching and output.

In another 1930s exhibit called "Machine Art," industrial and furniture design was put up on an art museum's wall for the first time. These found a permanent niche in the design galleries on the top floor.

Visiting the MoMA in the 1990s, one couldn't help noticing how much the original dream had faded. Barring temporary shows, the newest art dates from the 1960s. The permanent collection is preponderantly European. To judge by this sampling, art ran out of steam in the 1970s.

"Modern" no longer means "contemporary." It means a particular era in the past.

The museum is adding a new wing for contemporary art. It will reorganize itself from top to bottom. But no matter how you slice it, there is a contradiction between "museum" and "avant garde." In any case, what can we learn by seeing Cindy Sherman next to Picasso? Are they really part of the same thing?

The Design Collection, which used to make news by adding products to its collection, was the first part of the museum to shut down. Some of the early plastic objects have been melting and starting to smell.

Although it was created for new and unconventional art, the museum has a tone more haughty and exclusive even than the Metropolitan Museum, which has its Lehman Collection and Annenberg Rooms. Wealthy donors turned MoMA into a treasure house, not a laboratory for new ideas.

The white, angular interior which gave the Bauhaus the simplicity of a community center has been turned here into something fancy and expensive. Stairways are replaced by escalators. Marble sneaks in to dress up the floors.

Good taste never did become cheap. Le Corbusier's stripped-down metal recliner costs more than a sofa bed. For the price of a Charles Eames molded plywood side chair (first displayed in a design show at the Museum of Modern Art), you could buy ten director's chairs. Furniture makers known for good design, such as Herman Miller and Knoll, don't make their money from the general public. They sell to companies, who pay a premium for museum-class merchandise. To be fair, their wares are well-built. Eames's black Naugahyde and aluminum sling seating has outlived many of the airport waiting rooms in which it was originally installed.

Of all the chairs designed by early modernists for mass production, the only available affordable one is Marcel Breuer's tubular metal model.

What happened to the movement's egalitarian ideals? Why did the Russian Revolutionaries trade modern design for wedding cake architecture and Socialist Realism? Why did millionaires turn out to be modernism's biggest promoters? Seagram and Chase Manhattan and Lever Brothers and Time-Life filled New York with modernist buildings, stuffed them with Knoll furniture and abstract paintings.

Today's art, by contrast, doesn't interest companies. While Japan has been building modern art museums, American companies have been selling their collections.[1] Only the tobacco companies are still trying to buy goodwill with art shows.

Modern art and design didn't offend the bourgeoisie after all. It has even been said that modern artists, brooding, defiant loners, were the high priests of Cold War capitalism.[2] The 1950s were the age of the Western, and Jackson Pollock was a high culture cowboy.

[1] "Sara Lee Is Donating Impressionist Art to 20 U.S. Museums," *New York Times*, June 3, 1998, national edition, page B1.

Abstract painters used to be profiled in *Life* magazine. Can you imagine a painter on *Entertainment Tonight*?

Our weird art proved how free we were compared to the Soviets. It was good *because* nobody really liked it. As a showcase for our free society, the Museum of Modern Art was far cheaper than say, rebuilding the slums.

Then as now, modernism was an acquired taste. The Museum of Modern Art used to award manufacturers a "good design" seal, encouraging shoppers to do the right thing. Good design is what children don't reach for. That is, despite its democratic pretensions, modernism filters down from the top. It didn't set out to be popular, just good for you.

Explaining how modern architecture will revitalize the world's cities, Walter Gropius wrote, "The fear that individuality will be crushed out by the growing 'tyranny' of standardization is the sort of myth which cannot withstand the briefest examination. In all great epochs of history the existence of standards—that is, the conscious adoption of type-forms—has been the criterion of a polite, well-ordered society; for it is a commonplace that repetition of the same things for the same purpose exercises a settling and civilizing influence on men's minds."[3]

People didn't flock to the stores to buy "Wassily" chairs or Lauffer stainless steel or Marimekko garments. So these "functional" products never achieved the economies of scale that were supposedly designed into them.

[2] Serge Guilbaut, *How New York Stole the Idea of Modern Art*. Chicago: University of Chicago Press, 1983.

[3] Walter Gropius, *The New Architecture and the Bauhaus*. Cambridge: M.I.T. Press, 1965, p. 37.

In other cases, such as Mies's Barcelona chair, the designer didn't care about price, and a visually simple design cost a fortune. Mies had his original pigskin cushions made by Berlin's finest upholsterers.[4] These days a Barcelona chair goes for $3200.

Certainly, there are good functional designs which can be bought at a discount. For example, stainless steel sinks. When they first appeared, they looked as raw and uncongenial as steel teeth. Now they are the standard thing—cheaper, lighter and more durable than enameled steel. I could also cite power tools, track lighting and plastic lawn furniture.

Microwaves, toasters, coffee makers, irons and other plug-in kitchen appliances have clean lines, and use plastic to do what plastic does best. Computer gear mostly confirms the idea that "less is more." So do bicycles and farm machinery.

And modern architecture is not dead. Japanese architects Tadao Ando and Yoshio Taniguchi still treat concrete as an inherently beautiful medium. Fumihiko Maki makes boxlike, metal-sheathed buildings like this one.

[4] George H. Marcus, *Functionalist Design*. Munich: Prestel, 1995, p. 109.

Richard Meier continues to design white, flat-roofed multi-tiered buildings with big windows. They are hard to distinguish from this 1929 Los Angeles house by Richard Neutra.

Meier's hilltop Getty Museum is a strange collision of modernist purism with big money, big egos and palm trees. Blessed with an open budget and timetable, Meier's job was to generate a masterpiece, not to be a thrifty functionalist. So the Getty's plain white buildings exhibit every conceivable variety of scale and orientation, open and closed space, transition, light, shade and silhouette that Meier's Caribbean cruise ship vocabulary can achieve. The Getty is a modernist Parthenon (probably a contradiction in terms).

What Replaced It?

A move to dump the machine aesthetic got started in the 1970s. Architects sent out signals that their profession had become too serious, too uplifting, too bound by the rules. They wanted some room for personal expression, for the unexpected and fanciful.

Robert Venturi fired the first shot. He followed up a 1966 book called *Complexity and Contradiction in Architecture* with a glowing study of Las Vegas, where ideas such as "honesty," "truth to materials," and "human scale" never took hold.

His architecture of the same period makes exaggerated concessions to popular taste . . .

. . . and exaggerated allusions to buildings of the past. He and his partner Denise Scott Brown wanted to restore something architecture had lost—historical memory, the expressiveness of metaphor, and a tone of voice which may be hard to catch, but is never the cool superiority of Mies van der Rohe.

A silly building, or a very mannered building, is a kind of street theater. It doesn't claim to be good for us, just good-looking. Its architect isn't showing us what we need.

A Philippe Starck chair encourages you to care about mere appearances—makeup, tube tops and platform shoes. It is a joke on the modern, cheerfully non-functional. To ride a gazelle is, after all, far more challenging than sinking into a comfortable chair.

Although they are self-indulgent, there is also a kind of modesty in these flashy designs. They aim to please, not to teach. The designer dives into the shifting currents of fashion. He is willing to be the flavor of the month, not trying to write the last word in the history of design.

As a consequence, it is hard to think of a classic of postmodern design. What is today's equivalent of the Barcelona chair, the Porsche, the Eames lounge chair, or Noguchi's Akari lanterns, which every designer and architect wants to own?

I can think of a few:

1. Architect Michael Graves's teapot. This design bridges the gap between postmodern whimsy and modern seriousness. It has both. The whimsical details are stuck onto a modernist core (geometrical solids, industrial materials).

2. Philippe Starck's toothbrush. It cleans your teeth without looking like a surgical tool. Why should form follow function? Doesn't a clown head cookie jar work as well as mucous-colored Tupperware?

Postmodern design, despite its aversion to rules, has produced formulae of its own. To parody modern solemnity, architects swerved off the rectangular grid.

Peter Eisenman made colliding boxes his trademark. He borrowed a term from the philosopher Jacques Derrida—deconstruction—for this move. Ever since, people have used the word as a synonym for "pulling apart." Of course, if Derrida had meant "pulling apart" he would not have coined a new word.

Zaha Hadid cuts her corners even sharper. She sketches new designs by slashing a piece of paper with an Exacto knife. She is celebrated for beautiful renderings of unbuilt projects. Why not? There was a building slump in the '80s and early '90s. Only Japan was booming. If there is no customer to curb your imagination, why not let it run wild?

In recent years Hadid has built some rectangular buildings. But for a long time her best-known work was a crooked firehouse for a German manufacturer of high-end furniture.

Another milestone in postmodern design came when the Walt Disney Company started going after big name architects. Happily accepting the work, those architects signaled that high culture and pop culture, cutting edge design and Hollywood, now fit comfortably in the same bed.

The Disney architects—Arata Isozaki, Michael Graves and Robert A.M. Stern—seem to agree that architecture is show business, too. They built monuments—odd, overwhelming, and heavy on the topping. I'm sure they mean these buildings to be "exuberant." But can a building be exuberant?

As time went on, the postmodern movement spawned a new set of architectural clichés—outward-leaning façades in burnt orange and chocolate stucco, circular windows, shiny details. It's now okay for college libraries to look like Hong Kong hotels.

Another rebound from modernism is Sir Norman Foster's Star Wars style. At first glance it looks ultramodern. Then you realize the engineering is pure decoration.

Santiago Calatrava's recent work is a kind of throwback to the World's Fair futurism of 1939.

The postmodern reaction transformed more than architecture. In graphic design, ornate type styles reappeared, then died out again. Computers make it easy to distort and even blur type; designers used these tricks to fight the pomposity of the printed word. Layouts became more labyrinthine, less clear. Color choices—pastels, Sunday comic colors, fluorescent and metallic inks—purposely violated modernist taboos.

In industrial design, the counterrevolution started in Italy. Italy has smaller-scale manufacturers that don't have to sell a million chairs or place settings to pay their tooling costs (not that their products are cheap).

Ettore Sottsass and Memphis, the Milan design studio he helped to found, were a fount of irreverence, color and originality in product design. Their counterrevolution reached American furniture stores in highly diluted form—wrought iron, leopard-skin prints, stuffed leather chairs, streamlined lamps. But then, high modernism never got to furniture stores, either.

In electronics, the postmodern reaction took an organic turn. Straight lines and sharp corners gave way to curves and bulges. Nevertheless, TV sets and computers have always looked pretty modern.

In each of these examples, the next thing after modernism was a reaction, not an invention. Post-modernists want perpetual anarchy, not another one-size-fits-all system.

Designers weren't the only group to reject modernist orthodoxy. In the 1980s, in symposia in New York, veteran leftists rose to flagellate themselves for ignoring the totalitarian side of Marxism, for pretending that Stalin was just an exception. People like Susan Sontag confessed to intellectual snobbery and political correctness. Moralizing systems of belief—utopian programs—were on the way out. Although bourgeois democracy has given rise to half-baked leaders like Warren Harding and Rutherford B. Hayes, at least it never gave us monsters like Enver Hoxha or Nicolae Ceacescu.

But is it really possible to love mediocrity? Though the economy may be booming, prosperity hasn't fixed up schools or transit, housed the homeless and mentally ill. It has filled prisons to the brim. Isn't the pendulum due for a swing back toward utopian principles?

Designers act on professional principles every day. Buildings, furniture and web sites have to work. Design will always have a practical, prescriptive side. Maybe it's not a bad thing.

Modernism made peace between engineers and designers; it codified design along rational lines. That is not to say that it turned designers into clones. As my friend Grace Sullivan observes,

> Design always works backwards before it goes forward. No one starts with an abstract problem and proceeds in a rational, linear fashion to magically arrive at an embodied design solution. It would be like doing math without numbers. People start by turning away from the problem, moving backwards, using metaphors, looking to what's already been done, to other fields, to whatever happens to be there for inspiration and ideas. They sometimes find things by chance or accident or while playing with peas and toothpicks. Maybe this is obvious. But if it's the case, then the rationale that justifies a new design is always just as creative as the design itself—it's something that people make up, a way that they defend or interpret a structure rather than a meaning that's inherent in the structure. Maybe modernist principles and systems were more potent after the fact (of designing something) than they were

as actual methods. Maybe they functioned more as (internalized?) criteria determining which ideas to trash and which to privilege than they did as generators of new ideas. Or they allowed for a whole new category of ideas to be acceptable.[1]

This is an important point—"rational" design doesn't mean mechanical or dogmatic design. Even scientific experiments, the most rational procedures man can devise, start out with wild surmises and wacky intuitions. In the salad days of modernism, when "creativity" was a constant preoccupation, people worked on tricks to free the design imagination from old habits. Books about "lateral thinking" and "synectics" were popular with the very designers who are now remembered as hopeless squares.

Creating design has never been a rational process. It was the goals that were— air, light, clarity, efficiency. Postmodernists like Rem Koolhaas and Philippe Starck act on their spontaneous likes and dislikes. But they still spend most of their time making things work.

Can postmodern irony and modernist conviction be brought into a complementary relation?

[1] E-mail, December 16, 1997

What Comes Next?

In 1978 Frank Gehry turned his Santa Monica, California house into an anti-modernist manifesto. It started out as an ordinary salmon-colored house on a tree-lined street. He skirted it with a false front of corrugated metal and crowned the new conglomeration with tilted panels of chain link fence. He tore out old walls and bridged some of the resulting gaps with glass, some with plywood. Nondescript rooms acquired irregular dimensions. Inside, he let the signs of dismantling show.

The result is like an ordinary house repaired after an earthquake with material salvaged from the dump.

Gehry used the same materials and hinted at the same illogic in other projects. But the house remains one of a kind. It stands out for its outrageousness. It makes neither functional nor aesthetic sense. It is like black lipstick or Kool Aid-colored hair, declaring, "Look! I think I'm beautiful and if you want to like me you better like my attitude, too!"

When big commissions started pouring in, Gehry had to find other ways to be unconventional. Companies and institutions wanted the Gehry panache, but they also wanted their buildings to look new and expensive. He did buildings faced in glass, stucco and limestone, with curved and tilted asymmetrical facades.

Gehry went to great lengths *not* to produce Bauhaus-like rectangular volumes patterned with windows. Sometimes the novelty went more than skin deep. The Vitra Museum in Weil-am-Rhein, Germany, has arresting gallery spaces. Still, not as wild as Saarinen's TWA terminal.

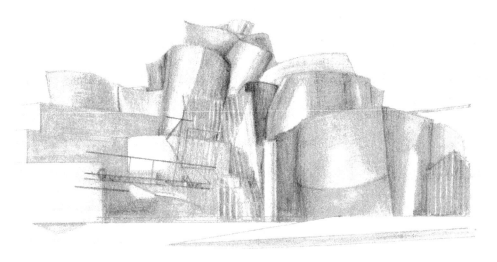

The successful Gehry did not stop having unconventional ideas—he advised AOL Time Warner to strip the walls off a historic Times Square skyscraper and wrap the frame in chain link fencing. But paying clients wanted a trademark building with a tilting, screwy façade.

By Gehry's account, the Bilbao Museum in Spain did not well up from the recesses of his imagination.[1] The client specified a building like the Sydney Opera House (which in turn has a lot in common with another sculptured landmark, Le Corbusier's Ronchamp chapel). Gehry can't take all the credit for the building's showy appeal. And since his model was a modernist classic, he is not disowning modernism either.

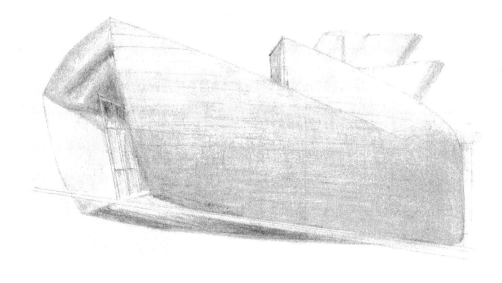

[1] Interview with Zahid Sardar, *San Francisco Examiner Magazine*, February 15, 1998, p. 6.

Gehry boasts about the aircraft titanium skin, and the software that helped architects and contractors imagine and build complex curves.

He talks about the building's fit with its urban context and how people circulate within it. He criticizes Frank Lloyd Wright's (New York) Guggenheim building for upstaging the painting and sculpture. In short, he sounds like a functionalist. As, indeed, all architects have to be.

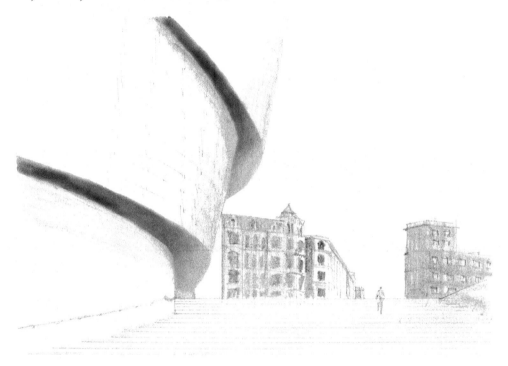

Gehry is pointing toward a common ground between the modern and post-modern, a place where the two no longer conflict. Is he the only designer there?

Michael Graves's teapot exhibits the same kind of creative ambiguity. So does this Richard Sapper design from the same Italian manufacturer, Alessi.

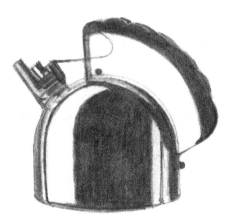

Another harbinger of reconciliation is this Philippe Starck knockdown chair. It is both mechanically clever and stylishly dressed. Form follows function *and* fashion.

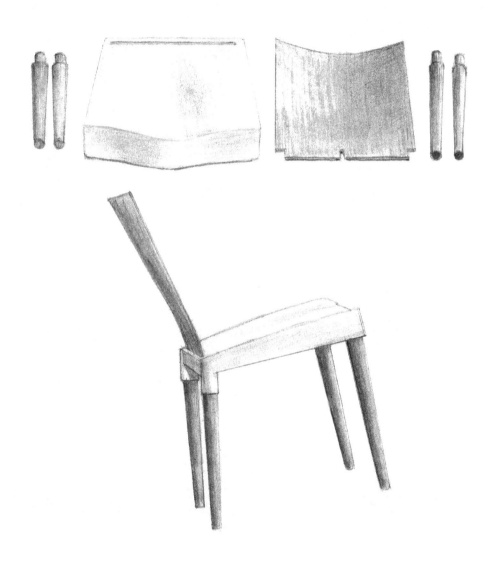

Part II
Was the Bauhaus Right?

Modern design was a gospel. Its high moral tone enabled designers like Charles and Ray Eames to sound like public servants, not salespeople. Modernists believed the world was getting better, and they were leading the charge.

After World War II, the world caught building fever. America built an interstate highway system. Townspeople agreed that their schools should be nicer than their homes. The election of Ronald Reagan in 1982 marked the end of that upbeat period.

Against their leaders' advice, union members voted for Reagan. The social engineers could no longer claim to be the voice of the people. Modernism's Big Plan was discredited. Government cut back and beggars appeared on the streets. In California, voters halved their property taxes. Test scores dropped to the bottom rank. Yet voters seem unwilling to raise taxes.

Once it lost its political momentum, modern design also lost some of its sheen. Part II of this book documents the painful realization that the Bauhaus invented a style, not a system. Modern architects and designers did not marry form and function as seamlessly as they hoped.

Modernists wanted design to grow out of a problem, not the designer's whims. They felt that just as there is only one physics, there should be one optimal design solution. But a strictly functional design does not require a designer, only an engineer. And in any case, function does not translate smoothly into form. Money is an important factor. You can always buy more function, more floor space, more design time, better materials and construction—a functional mansion or a functional hut. Furthermore, modernist designers thought no-nonsense models—Euclidean solid geometry and machines—would ensure sensible design. This assumption was naive.

Tastes have now swung back toward the ornate and the frivolous. The world did not accept "design" as a remedy for society's ills.

Trying to see where modernism went astray is not a destructive process. It opens the way to new ideas. Peeling away false promises will leave a core of truth.

The Language of Vision

Although modern design may look stiff—hard, shiny, and cold—Bauhaus theorists thought they were liberating humanity from cultural taboos. They were attracted to a new German school of psychology called Gestalt, meaning "form."

Gestalt psychology, unlike Freudian psychology, was based on objective scientific experiments. It starts from the idea that perception does not occur in a steady stream, but in leaps of realization. We don't perceive a field of colors. We perceive forms—people, trees, sidewalks. All of our thought is a traffic in forms—clusters of sensory data and ideas. Gestalt psychology looked for patterns of learning and thinking that are shared by all test subjects.

The kind of experiment that particularly intrigued Bauhaus designers was the optical illusion. To take a familiar example, a white square in a black field looks bigger than its negative image.

Exercises of this kind prove that the human brain has predictable responses to forms and colors. Lighter colors seem to come forward, darker to recede. Some pairs of colors (red/green, violet/yellow, orange/blue) are more pleasing than others. Artists have always had a vague grasp of these principles. It seemed

apparent in 1919 that a clear understanding of them might enable us to communicate without words.

The Bauhaus introductory course was taught by painters who were especially interested in that possibility—at various times Johannes Itten, Paul Klee, Wassily Kandinsky, Josef Albers, and Laszlo Moholy-Nagy. Children's art seemed like a good place to learn this visual language. Since they were unschooled, it was assumed that children must be using the inborn vocabulary of visual communication.

Children's drawings translate what they see into simple, generalized forms. They use straight lines, circles, squares and triangles. They do not indicate distance by differences in scale or elevation. They show flattened, frontal versions of things. And they limit themselves to a small palette of pure colors.

It certainly didn't seem like a coincidence that Euclid ordered and quantified physical space using lines and regular geometric forms—square, triangle, circle. Bauhaus designers came to assume that Euclidean shapes and pure, strong colors are the vocabulary of visual language.

Most modern design pioneers in Europe and America got this idea in kindergarten.[1]

[1] See Norman Brosterman, *Inventing Kindergarten*. New York: Harry N. Abrams, 1997.

Kindergarten was an Enlightenment idea: education should not pump knowledge into children's heads, but help them use what they already know. Friedrich Fröbel, the 18th century founder of kindergarten, believed that even 6-year-olds bring a fund of useful knowledge to school. To help them make creative use of their innate abilities, he designed wooden blocks, packs of colored sticks and paper shapes. Children were invited to make symmetrical patterns on tables ruled like graph paper.

Most modernist pioneers, from Mondrian to Buckminster Fuller, played with Fröbel's teaching materials.

Fuller liked to tell how he happened upon the building block of his geodesic domes, the tetrahedron. He was a child in school, doing a Fröbel exercise—building three-dimensional shapes from toothpicks jabbed into peas. He found that the figure with sides that are equilateral triangles was the hardest to tip, to distort or to crush. The cube, by contrast, could not withstand diagonal pressure.

Modern designers were looking for simple, universal forms to revitalize design and bring it into the machine age. They were encouraged in this quest by a 1917 book, *On Growth and Form*, by D'Arcy Wentworth Thompson. Thompson set out to "correlate with mathematical statement and physical law certain of the simpler outward phenomena of organic growth and structure or form."[2]

Form is a "diagram of forces."

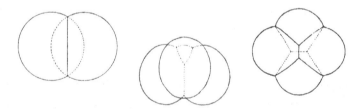

Dividing cells and floating soap bubbles aggregate in the same way.

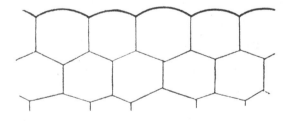

[2] D'Arcy Wentworth Thompson, *On Growth and Form*. Cambridge: Cambridge University Press, 1959, p. 14.

When dozens of equal-sized soap bubbles come together, they form a hexagonal lattice (embryos cease to arrange themselves so neatly once they grow beyond four cells.). This hexagonal lattice can be found throughout nature—in crystals, exoskeletons, honeycombs—for reasons comparable to those that govern soap bubbles.

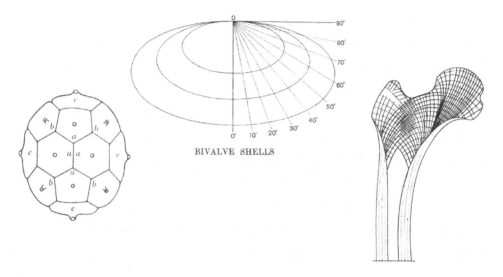

BIVALVE SHELLS

Thompson goes on to show how cell division can produce horns and antlers, teeth, spiral patterns in shells and plants, tubes, shells, leaves, bones. His goal was to quantify biology. But his work gave formal inspiration to designers—Frank Lloyd Wright, Buckminster Fuller, Eero Saarinen, Pier Luigi Nervi and Charles Eames. Nature, they could argue, was showing them the way just as history guided 19th-century design.

Buckminster Fuller could look at the skeleton of a microscopic sea creature and conclude that his domes have the survival qualities of a highly evolved organism. He thought he was accurately quoting the laws of nature.

We like regular geometry. The earliest known human adornments are circular beads carved from bone or shell. Materials scientists discovered a spherical carbon molecule, a lattice of polygons stitched together like the covering of a soccer ball.

The molecule's discoverers called it Buckminster Fullerene—Buckyball for short. The name humanizes the discovery—as if Fuller's mind mirrors the workings of the universe.

But circles, triangles and squares barely figure in the laws of nature as we now understand them. Physicists tell us that subatomic particles are not miniature solar systems. Electrons are not little balls. Subatomic particles have properties such as "spin" and "color" that cannot be visualized, only expressed in equations. String theory doesn't look like anything we've ever seen.

Geometric forms appealed to Bauhaus designers because they looked new, impersonal, and sensible—in tune with a technological age. These hammered copper vessels by an early Bauhaus student still have Art Nouveau-inspired handles.

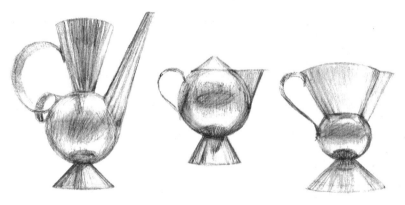

A wooden container and its legs echo the form of a tree trunk. Although it is visually simple, it must have been very hard to make.

In 1922, the provincial parliament of Weimar changed hands and the Gropius regime at the state art school ended. Gropius found a new host for the Bauhaus in Dessau, a manufacturing town. The school's emphasis changed from integrating arts and crafts to humanizing industrial design. Euclidean solid geometry had a fresh appeal to Bauhaus designers as a kit of simple, logical forms that should lend themselves to mass production.

A Bauhaus lamp of glass and steel lacks the fussiness of a traditional table lamp. But it started out as a handmade prototype whose designers were only guessing about industrial practices. When it did eventually reach the market, I doubt that it was cheap. A museum replica sells for $700.

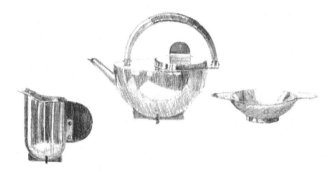

Bauhaus metal designs were built from regular geometric solids. They borrow the precision and uniformity of machine-made things. But they are one-of-a-kind handicrafts.

Danish designer Arne Jacobsen's Cylinda line of stainless steel tableware finally did put Bauhaus geometry into mass production. It is still on the market. But something tells me it is not easy to produce. A coffee set costs $450.

A quick search in a variety store shows that cheap mass manufacturers don't go in for plain geometry. The cheapest glasses are clear plastic, faceted to look

like cut glass. The cheapest plates have fired-on patterns. The cheapest

silverware comes in a Lily of the Valley design. Decoration is not inherently expensive, nor is simplicity inherently cheap.

In any case, the school's stress on geometry preceded any concern with mass production. In the Weimar years, the school was concerned with summoning artists back to the technical world to revitalize craft tradition. The school's first building project was not low-cost housing, but an Arts and Crafts mansion, the Sommerfeld house.

Everything was hand-crafted: wood paneling and doors, fabric hangings, stained glass windows, metal grillwork. As if to stress its artisanal nature, the shell of the Sommerfeld house is a log cabin, with projecting bays to multiply the corners where stacked log construction is evident.

The modernist angle, the difference from William Morris, was that patterns were abstract and geometric, not intertwining leaves and berries. Euclidean shorthand came to the Bauhaus even before the Bauhaus became interested in functionalism.

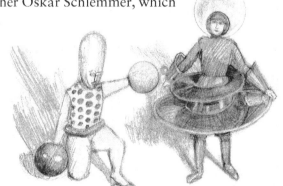

The founder of the introductory course, Johannes Itten, was not a functionalist but a mystic. He was looking for the atoms of visual experience—the "archiforms" that, multiplied, add up to what we see, and the rules that govern our reactions to color. Students did abstract exercises in color, line, and solid form.

They were feeling their way toward a grammar of visual experience. Their exercises translated landscape and the human form into cylinders, spheres and cubes. Or better yet, created new bodies and landscapes out of cylinders, spheres and cubes.

The funniest examples of this geometrizing tendency were the theatrical costumes of Bauhaus teacher Oskar Schlemmer, which fatten the players into geometric solids.

The costumes went well with figure-drawing classes where human bodies were rendered as diagrams. One photo

shows Schlemmer's students drawing a life-size articulated wooden dummy instead of a human model.

Schlemmer's theatrical works were largely wordless. Slippery words were supplanted by trustworthy vision.

Rosalind Krauss has written about a faith in the sense of sight, its innocence and truthfulness (in contrast to language, in particular) that runs through modern art from Ruskin to Frank Stella.[3] The Bauhaus curriculum, although it was always being updated, never stressed reading and writing. The students designed books, but avoided reading them. The idea was that the generality of language discourages precise observation.

The geometric vocabulary of the early Bauhaus was related to *de Stijl* (Style), the Dutch school which produced Mondrian, to the typographic collages of the Dadaists and Futurists and the spidery geometries of the Russian Constructivists.

Following the Bauhaus lead, Euclidean geometry became an article of faith in modern design.

Buckminster Fuller's dome is a prime example.

[3] Rosalind Krauss, *The Optical Unconscious*. Cambridge: M.I.T. Press, 1993.

Fuller domes are no longer built, as far as I know. A few still shelter radar antennas. Their scarcity casts doubt on the inherent functionality of regular geometric solids.

The geodesic dome looked like a triumph of engineering—a sphere on a framework of linked tetrahedra. People have always been intrigued by hemispherical buildings. They are more egglike and inviting than a cube. The ball shape seems to come from nature, not from architectural history.

By contrast, domes for optical telescopes look low tech—sheet metal triangles bolted together. Why did this pattern win out over Fuller's? Is it possible that the geodesic dome was overbuilt?

A sphere is the smallest surface required to contain a given volume. But unless you are garaging an elephant, you have to build floors in order to use the space. That calls for a rectangular framework. And a dome is a very inefficient way to cover a box.

If you build floors out to the dome itself, the problem is concave walls. Making a shelf, or a desk, or a bed or a dresser to fit a rounded wall is a nightmare. All the wonderful ways we've found to cut and assemble furniture—saws, planers, metal benders, drawers—depend on parallel edges and 90° corners. Another problem is the odd-shaped rooms, sliced from a pie. To compound these problems, it's hard to weatherproof a curved surface. Shingles, for example, won't lie flat.

Although the dome is an intriguing proposition, it was a bad design. Vertical walls and flat roof planes are a "diagram of forces" perfectly suited to gravity. The claim by the Bauhaus and its successors, to have dug down to the simple, true basics of design, was overconfident.

The reappearance of a beetle-shaped Volkswagen as a retro novelty reminds us that Euclidean geometry—arcs and straight lines—was never inherently functional. Having become truly aerodynamic to meet fuel efficiency laws, most cars now look like worn bars of soap.

The dream that design could have a new psychological authenticity took another form in the internationalized world that emerged after World War II. Gyorgy Kepes, a student of Bauhaus teachers in Chicago, concluded his 1944 book *The Language of Vision* with the hope that well-designed advertising could be a kind of visual calisthenics :

> Here lies a great challenge for advertising today. Contemporary manmade environment makes up a very large part of man's visible surroundings. Posters on the street, picture magazines, picture books, container labels, window displays, and innumerable other existing or potential forms of visual publicity could then serve a double purpose. They could disseminate socially useful messages, and they could train the eye, and thus the mind, with the necessary discipline of seeing beyond the surface of visible things, to recognize and enjoy values necessary for an integrated life . . . preparing the way for a positive popular art, an art reaching everybody and understood by everyone."[4]

This same dream led to intensive work on internationally legible symbols in the 1970s.

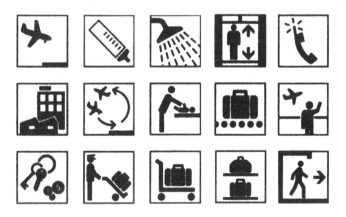

[4] Gyorgy Kepes, *The Language of Vision*. Chicago: Paul Theobald, 1944, p. 221.

In the '80s, screen icons for computers promised to be a new shortcut between the eye and the brain. But the severe limitations of all such symbols soon became obvious. Ask yourself which is clearer, the words "men" and "women," or skirt/non-skirt icons on restroom doors. Then, try to imagine a novel in the "language of vision." (Hint: it's about Superman.)

Glass

Walter Gropius made his name with the curtain walls of the 1912 Fagus Building. The most strikingly novel aspect of his Bauhaus building in Dessau is a three-story glass wall. Mies van der Rohe went even further with glass. Glass has been the mark of modern architecture ever since. It is honest, concealing nothing. It is

new; older buildings had huge windows, but never appeared to be made of glass. It is healthy, bringing sunlight indoors. But are glass walls really practical?

When you look up at a glass skyscraper, you often see a wall of curtains or shades. Or black or mirrored glass. Direct sunlight is too bright and hot for most work situations. The view from inside may be great. But a view requires only a window, not a glass wall.

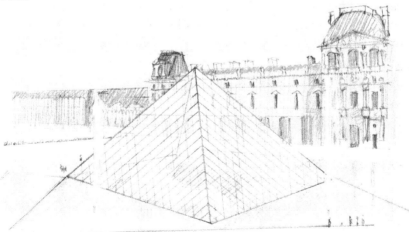

Paris, the city of light, is becoming the city of glass. Like high fashion, glass is not always comfortable. I.M. Pei's glass pyramid for the Louvre is a solar oven on sunny days. The new National Library, a quartet of glass towers shaped like

open books, blithely disregards the fact that sunlight is bad for books. Every window has now been blocked by a blank wooden door.

The Center for the Arab World in Paris has window walls shaded by motorized irises which close when the sun brightens. The screen alludes to Moorish grillwork, which blocks light and admits air—just the opposite of what glass does. Next to another Paris commission—the Cartier Foundation—architect Jean Nouvel built a free-standing glass wall, as if to affirm his love for glass regardless of its use.

Supermarkets and department stores rarely have windows. They need the walls for shelves and displays. For some reason, even skylights are out.

A skylit central atrium used to be a common feature of big department stores. Photographs of GUM in Moscow always look down into the central court.

Some malls copy this idea of a skylit indoor street. But the exterior walls are windowless. Clearly, windows are not always functional.

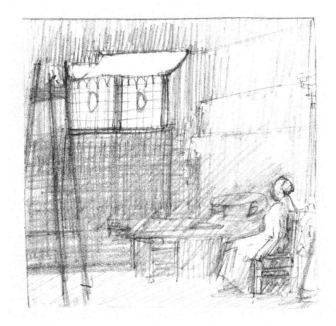

Artists' studios used to have skylights facing north. North of the equator, the sun's east–west path almost never goes straight overhead. So north-facing skylights see only indirect light, bounced in by dust particles in the sky. The light on the artist's model will always be soft and relatively shadowless, and will not change much in the course of the day.

In a drawing of his own studio, Rembrandt shows a tall window with the bottom half shuttered. The top half, which reaches almost to the ceiling, has a cloth shade like an awning, raised or lowered to block or bounce the window light.

Factories used to have sawtooth roofs—ranks of north-facing skylights. The work floor got consistent illumination, neither blinding nor hot. That seems like a good idea, although it looks strange from the outside.

The Bauhaus Archive in Berlin, designed by Gropius in the '60s, has such a roof.

Despite all this evidence that glass walls aren't necessarily a good idea, Mies van der Rohe's signature buildings—the icons of modern design—can be recognized by their glass walls.

The German pavilion at a 1929 World's Fair in Barcelona had floor-to-ceiling glass. The roof slab is supported by thin chrome-plated columns. The Barcelona Pavilion was used only for parties.

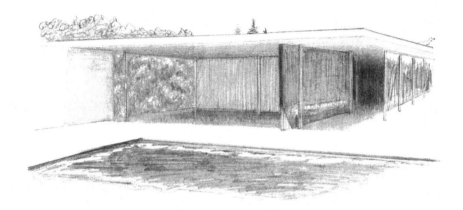

Another Mies classic, a country house for an Illinois doctor, is a glass box elevated above the floodplain of a nearby river. It was equipped with curtains, and had a service core which served as a room divider. It combined inadequate winter insulation with inadequate summer ventilation.

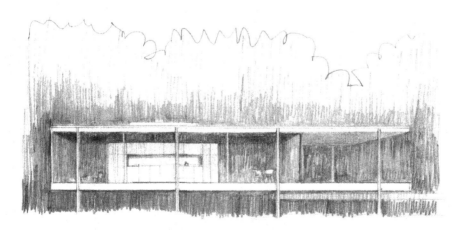

Philip Johnson built an even more delicate glass box. The only interior wall surrounds a cylindrical bathroom. Like the Farnsworth House, Johnson's box is far from prying eyes. Even so, he built a conventional house across the lawn for things you wouldn't want to do in public.

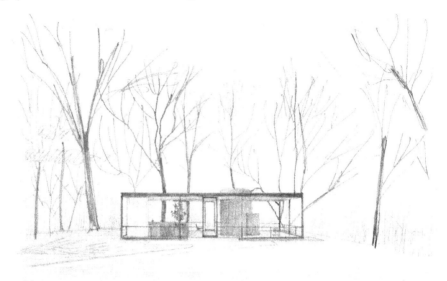

In the 1950s, Charles Eames tried to democratize the glass house. Commissioned by a magazine to build a model home, he made a relatively cheap glass box out of industrial components—steel trusses and factory window panels. It looks less refined than Philip Johnson's, but it served the Eames family well as a home.

The site was a tree-shaded hillside in Los Angeles, overlooking the sea. Passersby could not see in. Glass houses seem to work best on dramatic hilltop sites where privacy is not a problem. Glass houses never caught on in the suburbs.

They require acres of shades to moderate the sun. The shades can never be adjusted often enough and weather rapidly.

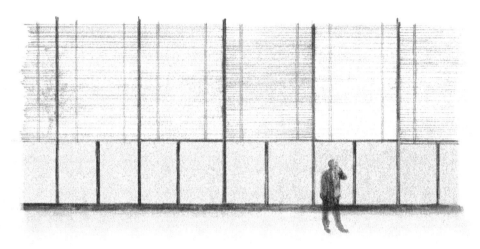

Mies van der Rohe's love of formal purity often fought with function. Critics have observed that his Design Building for the Illinois Institute of Technology in Chicago is a lousy place to study. Architecture students work upstairs in a huge glassed-in box. Design students labor in the basement. The upstairs studio was such a solarium that air conditioning had to be installed on the roof, cluttering the building's profile.

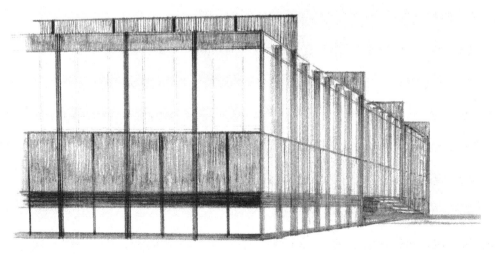

Mies proposed a glass box for a theater in Germany. A theater has to be dark, so another box was to be built inside. Since then, many a concert hall has been

housed in a glass box. Glass shows the public what they're missing, but otherwise adds little but sparkle. The showiest new glass box theater is James Polshek's planetarium at the American Museum of Natural History.

Mies built a glass box in Berlin to house an art museum. Since sunlight harms paintings, the actual galleries are underground. In this case, less hides more and form contradicts function.

French comedian Jacques Tati made glass walls a rich source of sight gags. *Mon Oncle* (1958) takes place in a glass house surrounded by a high wall. Visitors peer in through a gate; the residents have a beautiful view of a wall. In *Playtime* (1967), Tati looks for work in a glass office tower. He sees his destination but can never find the way in. When he heads home at dusk, a glass-walled apartment house puts all its residents' eccentricities on show.

The Bauhaus taboo against ornament made windows and rectangular volumes the architect's only playthings. The expressive character of a modern exterior has largely to do with windows.

Mies was praised in the '50s for the vertical lines of his glass skyscrapers. Vertical I-beams, welded to the outside of the building, dramatize the building's vertical lines of force. Tall, narrow windows reinforce the effect.

An early missionary of modernism, Henry-Russell Hitchcock, denounced vertical stripe effects in the 1932 catalogue to the MoMA "International Style" show. He condemned them as false Gothic striving toward God.

He praised the Bauhaus building's horizontal bands of windows. "Storeyed construction naturally produces horizontality,"[1] said Hitchcock. The Gropius model certainly did inspire the American motel—stucco walls, a flat roof, plain balcony and rows of picture windows.

Le Corbusier, by contrast, rarely made a spectacle of lightness and did not use curtain walls.

Le Corbusier liked concrete. He solved the problem of direct sunlight with concrete shadow boxes. But since they are so heavy, these permanent awnings now look a little overdone.

[1] Henry-Russell Hitchcock, *The International Style*. New York: Norton, 1995, p. 79.

Functionalism

Less Is More

Steel and glass look modern. Mies van der Rohe buildings look newer than Frank Lloyd Wright's because of the delicacy of his structures, their slender steel skeletons.

Steel is structurally efficient. It has a better strength-to-weight ratio than stone or masonry or concrete. But concrete is often a better deal. When officials decided to rebuild the eastern span of the San Francisco Bay Bridge, they came up with two alternatives:

A long concrete tray on slender piers was the cheapest.

A spidery steel suspension bridge cost more. The span crosses deep mud. There is a rocky foundation at one end only. The visually efficient design is not cost-efficient.

Regardless of that fact, the public, the taste makers, and finally the officials picked a one-pier suspension bridge. They wanted a bridge that looks like the Golden Gate Bridge and they were willing to pay more.

Elevated highways are built from reinforced concrete—concrete with an armature of steel rods molded inside. Poured concrete can take any shape: for example, complex and graceful curves.

It is much more weatherproof than steel and requires less maintenance. Elevated trains used to ride on steel scaffolding. Modern highway builders use concrete. More is more.

Le Corbusier embraced heaviness, molding sculptural volumes from concrete.

Concrete does not always look heavy. Pier Luigi Nervi built concrete roofs of startling thinness.

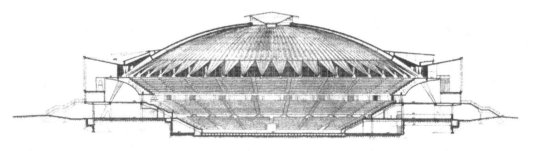

Eero Saarinen's TWA Terminal at John F. Kennedy airport in New York has a thin concrete shell.

Most modern designers, thinking "efficiency," went for lightness. Charles Eames always strove to do the most work with the least material. During World War II, he used a new plywood-molding technique to build gliders, redefining wood as an airplane material. His plywood chair is a byproduct of that effort. Still, can a $575 chair be called efficient, whatever its weight?

The all-time lightness nut was Buckminster Fuller. His three-wheeled, airplane-like Dymaxion Car was very fast. Tippy and fragile, it didn't stand a chance in a collision.

Fuller's first aluminum home design, the 1927 4D apartment house, was meant to be deposited in the wilderness by a dirigible. It was a self-sufficient habitat, part of a "one-town world" accessible via "air ocean." The dirigible was supposed to dig a foundation by dropping a bomb.

Fuller thought gravity was old-fashioned as a structural glue. He often complained that people have no idea how heavy their houses are. His diagram shows that an aluminum apartment house could weigh less than a single-family suburban home.

His substitute for the old-fashioned compression that holds buildings up was tension—structures held together by pulling. His student Kenneth Snelson designed several of these structures. He ended up selling them as sculptures. I wonder if Fuller ever noticed that the bike wheel is a tension assembly. So were early airplanes, conceived by bike mechanics. Fuller was looking backward.

Fuller's friend Isamu Noguchi loved the idea of doing more with less. One of his inspirations was the Japanese house—its pale tatami mats, paper windows, and lack of furniture. But traditional Japanese rooms are so fragile and so limited in function that present-day Japanese homes have only one, if any.

One useful product of Noguchi's Japanese researches is the Akari lantern, a paper lantern wired for electricity. It supplies diffused electric light with an absolute minimum of material. Simplicity is its chief visual strength. But at $150 to $500, it cannot be called efficient. The lanterns and their paper are handmade, and skilled labor in Japan is no longer cheap. Knockoffs of Noguchi's idea made elsewhere in Asia are, in fact, cheap.

Designers of sports arenas have long been attracted to fabric roofs. Because they weigh less than a solid roof, they require less support and are cheaper to build. They can even be supported by internal air pressure, as at the Hubert H. Humphrey Metrodome in Minneapolis.

But the Metrodome is a disaster. Its bulging shape won't shed snow and can't support a snow plow. When there is more snow than the internal heating system can melt, snowdrifts must be shoveled off by hand. The Metrodome and Montreal's Olympic Stadium have both been ripped and deflated by snow and ice. To make matters worse, the Metrodome's pale underside makes fly balls invisible. Both the Mets and the Vikings want a new stadium.

Inflatable furniture is likely to puncture. Plastic dinnerware never replaced china. Plastic windows, though they are unbreakable, scratch too easily. Sometimes heavier is better.

Surgeons and gardeners can slip on clogs without stooping.

Irons do some of the work of pressing. Heavy vases are more stable. Heavy pans spread the heat. Heavy cars are safer.

And visual simplicity is sometimes bad.

When modern architects started to design concert halls, their first impulse was to eliminate plaster cherubs and floral sprays, rosettes and chandeliers, velvet drapes and bulging semicircular balconies. They substituted sleek solid geometry.

But when you look up, you see a tangle of hanging lights and parabolic reflectors. Flat planes return harsh echoes, echoes that were diffused in older halls by baroque ornamentation. Surfaces must be broken up. Concert halls cannot be as visually simple as modern architects had hoped.

The machine as model

Aside from tea and coffee equipment, the Bauhaus did not design machines. Nevertheless, the machine was an ever-present ideal. The Bauhaus moved furniture, for example, out of the realm of handicraft into the realm of equipment.

Le Corbusier called his houses "machines to live in." Thomas Edison described biology as "meat mechanics." Ever since Newton imagined the universe as a clockwork, people have seen the machine as a model of ingenuity. Everything is there for a purpose. There is no dead weight.

Does that mean a tree is sloppily put together? Instead of a single solar panel,

it has a fluttering panoply of leaves to absorb sunlight and exchange gases with the air. Leaves let wind or rain through. Half of them can blow away without disabling the tree.

And what about seeds and eggs? Although few of their children survive, frogs lay enough to keep their species going. Extra eggs make up for a lack of parental concern.

The maple tree drops bushels of winged seeds. Fruit trees produce truckloads of fruit. Nut trees litter the ground with their genetic material. In a good year, one or two of these seeds might take root. The system appears wasteful, like releasing a hundred hats from the ceiling in hopes that one will fall on your head. But it works.

Redundant designs are common in nature. For example:

Feathers. Instead of a sail, birds use rows of overlapping fans. Feathers push the air in flight. They insulate and shed rain. If six or eight fall out, flight is still possible.

Fur. Hairs provide both warmth and shade.

Scales. A hard covering which flexes. Instead of a single coating, nature opted in both cases for redundancy.

We too have learned to scatter our seeds on the wind. For example, junk mail. If two percent of the recipients respond, the mailing is a success. Buckshot, land mines and other weapons also play the percentages.

PERSONAL AND CONFIDENTIAL

**AUTOCR **C011
1241094021465 028 028 CAP1
Leslie Bruns or Current Resident
3003 Calvert Lane
Bunstock, ME 07142-0166

There are happier examples of massive redundancy in the designed environment. Baths and showers use gallons of water to push around a few milligrams of dirt. Toilets also err on the side of generosity. Buckminster Fuller designed water-saving alternatives to each.

Something tells me a fog bath would be *cold*. And water is practically free. Until that changes, I'll stick with showers.

ONE PINT WATER = ONE HOUR MASSAGING PRESSURE BATH

AIR

WATER

FOG

There are redundant ways of making hard things act soft. Velcro. Styrofoam peanuts. Fish scale samurai armor allows the wearer to move freely while presenting a hard barrier to any direct jab.

Sequins split a mirror into wearable facets.

I can imagine a massively redundant way of plugging radiator leaks by pumping in thousands of soft spheroids. Only one would be required to plug the leak. The rest would be flushed out. Of course, I can also think of reasons why this wouldn't work.

Another thing worth noting about trees, frogs' eggs, feathers and fur: they are pliable. Imagining design in terms of machines may have deflected designers from soft solutions. Soft designs have revolutionized human life:

Weaving made possible clothing, sails, carpets, the tent, and the blanket. Some other great soft designs: paper, rope and wire, aluminum foil, toothpaste tubes, zippers, sponges, tires, gaskets and washers, bungee cords, corks and bags.

The mass-produced house

Architects have always supposed that mass production would drive down housing costs. Walter Gropius worked on a house kit of copper-sheathed wall panels. His disciples perfected components that could be interlocked in many ways.[1]

[1] Gilbert Herbert, *The Dream of the Factory-Made House: Walter Gropius and Konrad Wachsmann*. Cambridge: M.I.T. Press, 1984.

Thomas Edison proposed a concrete house, poured on the site in reusable forms. It turned out to require five hundred cast-iron molds, each weighing hundreds of pounds.

When I was young, Disneyland had a plastic house of the future sponsored by Monsanto Chemical. Four modular plastic rooms projected from a central pedestal. Somehow the future never arrived, and Disneyland got rid of the house.

Israeli architect Moshe Safdie showed an apartment house made from nested concrete modules at the 1967 Montreal World's Fair. Something similar was built in Israel. But the world has not embraced the idea.

Japanese architect Kisho Kurokawa foresaw an apartment house built from boxes snapped onto a service mast. The building can change with the times. Prefabricated boxes should be cheaper than custom-built structures. Kurokawa has designed fantasy cities with thousands of identical modules suspended from spiraling armatures.

It's an appealing idea, but it has problems. How do you fit all the functions of an apartment house into freight containers? Why bother weatherproofing all those boxes? A normal building needs only five weatherproof sides. And what about plumbing? Hallways? Wind noise?

Moscow apartment houses used to be assembled from factory-produced concrete modules, stacked by cranes. Maybe this idea works best in a cold climate—it allows construction work to be done inside. In any case, no one outside the East bloc copied it.

There are factory-built houses in America, delivered in trailer-sized sections and joined to form a bigger unit on the site. They seem to be popular only in rural communities, and their virtue is cheapness, not value.

One factory-built house has been an unqualified success: the mobile home. Its drawback is small size and tacky appearance. Contrary to Gropius's hopes, Americans don't want to live in identical boxes.

Two-by-fours, plywood and sheet rock have proved to be the most versatile modules. Builders do use prefabricated parts—door frames, windows and roof trusses. But most of the work is still done on the building site.

Streamlining

In 1919, when the Bauhaus opened, airplanes looked like kites—fabric stretched over wooden frames. Invented by bike mechanics, they exploited tension—guy wires stiffened the frame. But before long, planes began to look like bullets, offering industrial designers a mesmerizing example of functional design.

Architects saw the glass box as a fusion of form and function. An airplane was even more eloquent. Its performance completely dictates its appearance—fast, nimble and new. A glance tells you everything. Cargo planes look like moving vans. War planes look like darts.

Furthermore, no expense is spared. Aluminum, titanium, space-age ceramics . . . if they save weight or add strength, they're worth it. Unlike cars and trains, airplanes still have the glamour of cutting edge technology.

The bullet-shaped sheath that Raymond Loewy put around a steam locomotive had no discernible aerodynamic effect.

Loewy's Studebaker with the jet intake grille was no faster or more fuel-efficient than any other car.

His streamlined pencil sharpener has been derided as the ultimate in fake functionalism. Does a pencil sharpener need to slice through the wind? Why not derive its looks from its own mechanics?

This stapler of 1931 has the same ersatz functionalism. In his book *Objects of Desire*,[2] Adrian Forty reminds us that designers have to sell products. Mixers, vacuum cleaners and toasters come in housings that say "hygienic, up-to-date and powerful," not "a small electrical device."

[2] Adrian Forty, *Objects of Desire: Design and Society 1750–1980*. London: Thames & Hudson, 1986.

A cruder version of Loewy's teardrop is the standard American pencil sharpener. It works fine.

This French design is also perfectly functional. It's clear that functionalism—even in bridge and freeway design—leaves a lot of room for visual fancy.

At the end of his career, Mies van der Rohe turned the functionalist formula upside down. He decreed that function must follow form. Having built the beautiful Seagram Building without consulting the tenants, he invited them to use it any way they liked.

Smooth metal coverings give things a functional look. The inside of the Center for the Arab World in Paris looks like a space station. It is all metal, eschewing ordinary building technologies such as poured concrete and sheet rock.

The stairs are like shiny scaffolds. Glass elevators rise and fall in a glass atrium. Even the elevator weights are housed in streamlined metal. This functional look must have tripled the building's cost. Yet there is no reason to suppose it makes the building work better.

All-metal structures are expensive. They cannot be fixed or improved with ordinary building supplies. Buckminster Fuller advocated cylindrical aluminum buildings suspended from a central mast. The form reflects his love of airships and contempt for gravity.

After World War II, when aircraft manufacturers feared a slump, they asked Fuller to design a factory-built aluminum home. The 3,000-part home kit was to be delivered in an aluminum tube. A windvane funneled in fresh air. Two prototypes were built before his backers decided the idea was too expensive.

The prototypes ended up sitting on top of each other, a two-story turret on a Kansas vacation home. The Henry Ford Museum in Dearborn, Michigan has used the pieces to reconstruct Fuller's dream.

I once helped design a technology museum whose exhibits sat on custom-made tables with sleek metal skirts. Packed under the tables, out of sight, were the electronics and mechanical gear that made the exhibits work. Clean, uncluttered design hid a messy, but in some ways more impressive, reality.

The Pompidou Center in Paris goes to the opposite extreme, exposing its internal workings. Is it functional? Something tells me the pipes and ducts have been exaggerated.

The translucent iMac showed its insides, but you still can't see how it works.

Ergonomics

"Ergonomics" is one way industrial designers gauge function. It is the quest for an ideal fit between machines and their users. Tools should be conveniently scaled, controls easy to hand, perfectly balanced and contoured to fit the user.

This diagram from Henry Dreyfuss's firm decorated many an industrial design office. It suggests that products, like space suits, can perfectly conform to the human body. It also, however, reminds us that all bodies are not alike ("6 year old," "typical," "average"). And it shows a very constricted range of movement. The standing figures look like crossing guards, and the seated ones seem to be in wheelchairs.

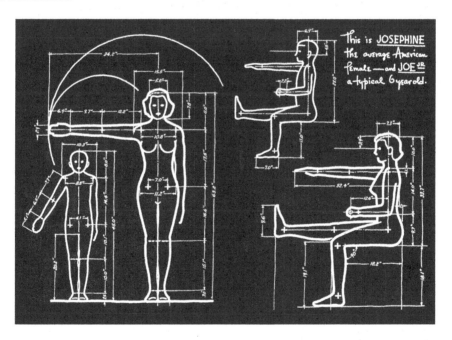

Though it's an appealing idea, ergonomics never became a science. A perfect fit requires a choice of sizes, which won't do for office products or furniture. In any case, carpal tunnel syndrome killed the idea that yielding chairs and cleverly-designed keyboards and mice will make office workers ever more productive. And style matters. Molded orthopedic shoes—that is, strictly functional ones—have never caught on.

I once visited the makers of a very good electric shaver. I was taken through a lab where people try out prototypes. I asked about ergonomic improvements. Is the balance improved? The head angle? The fit with the user's hand?

"We made our most ergonomic model in the 1970s."

"But aren't you always improving the ergonomics?"

"We change models to sell shavers. If they don't *see* improvements, people keep their old ones (which last forever). Digital readouts, floating heads, metallic finish—changes must be visible. Ergonomic improvements can't be seen, so they don't sell shavers."

I said how much I like their cheapest model, one without a built-in battery. They confessed to putting metal ballast in the empty battery compartment. Otherwise the customers, sensing that the motor is about as big as a cherry, would reject the shaver as a cheap plastic toy. Heft gives a "quality impression."

Charles Eames made a film about his fiberglass chairs. It shows young designers using a clever device to profile people's backs. Obviously, Eames's chairs were going to fit better than old-style chairs.

But when the new chair materializes it doesn't conform to the S-shape of the human back. The film doesn't explain why. I imagine it's because chairs have to fit all kinds of people who squirm around in a chair—slump, straighten up, cross their legs.

If ergonomics could guide us to the right form, wouldn't chair design be converging toward perfection? Chairs still come in all shapes and sizes.

People tolerate crazy departures from ergonomic principles. They don't want a chair to be a straitjacket.

Comfort is relative. Soft upholstered chairs can be uncomfortable.

And hard chairs can be relaxing. Eames's plywood and fiberglass chairs are as hard as a rock.

Harry Bertoia made easy chairs of heavy wire mesh.

Cloth slings, which have no inherent shape, can be comfortable, too.

If ergonomics were really a science, wouldn't airplane seats be comfortable by now?

Some expensive cars offer lumbar supports, inflatable to suit the user. I love the idea, but it must not be foolproof. If it were, other seats would have lumbar bulges.

Every year new, incredibly expensive office chairs come out, promising to ease the discomfort of sitting all day. Both seat and back respond to pressure. Height and resistance can be adjusted. The universal favorite has elastic mesh upholstery. At $800, it is the Louis Vuitton of chairs.

If ergonomics were a science, then all the tools that do a given job would eventually come in the same perfected shape. This is true of carpenter's tools, of safety razors, of mattresses, of bicycle seats and writing implements.

It is especially true of guns, designed to help a wobbly, breathing user hold a long tube steady at shoulder level. M16s, Kalashnikovs and Galils look alike.

But it is not always true. As with chairs, there are all different kinds of can openers, water faucets, cutlery, and cups.

The piano keyboard is an ergonomic masterpiece. Electronic music became popular once synthesizers acquired keyboards. The inventor of typing (and, by extension, the computer keyboard) must have had a piano in mind. Please note, however! The keyboard is not easy to use. You have to take lessons.

The same is true of chopsticks, the bicycle, the abacus and the helicopter. Good design is not simply a matter of adapting to people's limitations. It is also a matter of knowing what people can learn.

Telephones look alike only to the extent that telephone design has completely abandoned ergonomics.

To take the obvious example, cell phones are not handy, just small. The tiny keyboard is a chore. Only the antenna tells you which way is up. There's no conformity to human head or hand. You can buy an ergonomic cell phone—a headset. But most people find it odd.

To sum up, functionalism was never the all-purpose answer it claimed to be. It was less rational than it liked to pretend, often just another look, like Art Deco or Arts and Crafts.

On the other hand, it will never die.

If you squint at a row of parked cars, you

will see that they are all essentially the same shape. Despite the manufacturers' need to be distinctive, functional considerations, especially fuel economy, have led them closer and closer to the same mold. A Ford Mustang looks uncannily like a Honda Accord.

I'm not mentioning S.U.V.'s, whose functional look is mostly a fashion statement.

The kind of variety you saw in the '50s cars, with bathtub Porsches, fighter jet Studebakers, crouching Jaguars and MGs, flying saucer Citroens, Volkswagen beetles and staid Rolls Royces is a thing of the past.

There is more variety in Europe, where four price brackets—micro, mini, medium and deluxe—make a visible difference.

Postmodern designers may put looks over usefulness, but they still make useful things. Frank Gehry set himself the classic functionalist challenge of building chairs from inexpensive materials—corrugated cardboard and basket splints.

This Philippe Starck door handle is both antler-like and perfectly practical. (He has made impractical ones.)

Social Engineering

Urban Planning

To alleviate an urban housing shortage in the 1920s, German tax law encouraged the building of cooperative apartment projects. This was a perfect opportunity for socially responsible architects. Walter Gropius and his modernist allies designed several such complexes, some as big as towns. All were successful. They offered light, air, green space, modern kitchens and plumbing. The money-saving trade-off was limited square footage and standardized, modular design.[1]

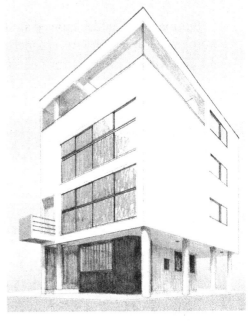

The best-remembered one is at Weissenhof, near Stuttgart. Organized by Mies van der Rohe to publicize "the new dwelling," this international pilot project had buildings by Gropius, Le Corbusier, J.J.P. Oud, Bruno Taut and Mies himself, all in white stucco with lots of glass.

Successes like these encouraged modern designers to believe they could solve big social problems—that a well-designed environment could make people happy, friendly and productive.

The 1939 New York World's Fair offered a preview of this future city.[2] Motorways would open up the dark, congested metropolis. Cities would fan out into a map of specialized destinations—office, store, homes—all accessible by car. The quality of life in tomorrow's city would depend on its traffic arteries (this vision has been realized in Los Angeles).

[1] Barbara Miller Lane, *Architecture and Politics in Germany, 1918–1945*. Cambridge: Harvard Press, 1985, ch. IV.
[2] Jeffrey L. Meikle, *Twentieth Century Limited: Industrial Design in America, 1925–1939*. Philadelphia: Temple University Press, 1979. See Chapter Nine, p. 189.

There was a miniature "Democracity" designed by pioneering industrial designer Henry Dreyfuss inside the huge spherical centerpiece of the fair.

Norman Bel Geddes showed another autopia in his GM pavilion. The sidewalks were raised above the streets, permitting General Motors cars to flow through the city without slowing for pedestrians.

Both designers were indebted to Le Corbusier, whose urban design schemes of the '20s and '30s reorganize cities the same way. Tall buildings open up space for gardens. Housing, offices and factories are sorted into separate zones. Schools, shops and institutions are tucked in between.

What looks odd about these schemes is that they were supposed to be built from scratch. They ignore the problems of real cities. Admittedly, two or three cities have been built from scratch.

One was Brasilia, Brazil's new inland capital built in the 1960s. Its designers, Oscar Niemeyer, Lucio Costa and Roberto Burle Marx, divided the city into zones connected by highways. The government zone is monumental and impressive. Shops are confined to commercial corridors. People live in park-like residential zones. The overall shape was derived from a passenger jet.

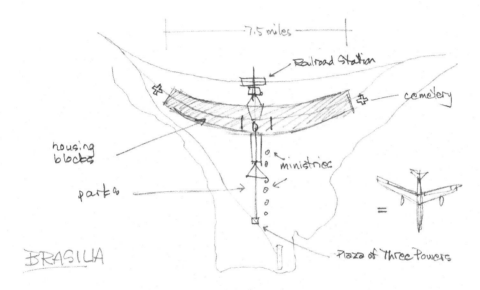

Forty years later, it looks awful. The grand buildings of the national government, arrayed like chess pieces on a paved plaza extending to the horizon, are rusted and cracking. With no variety in architectural style or materials, it is like a diChirico painting, a nightmarish confinement inside Oscar Niemeyer's head in the year 1958.

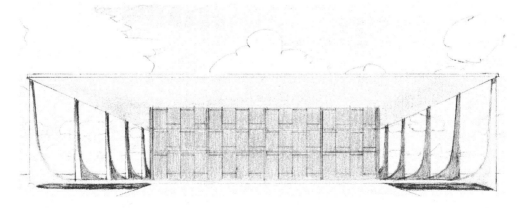

A second thing that went wrong was the systematic exclusion of all but a privileged class from the utopian city where government jobs are located. Brasilia now has sprawling suburbs where most of the workers live. Designed as an emblem of Brazil's future, Brasilia ended up reproducing the country's past.

Le Corbusier designed a new capital for the Indian state of Punjab when its old capital went to Pakistan. Chandigarh, like American housing projects of the same period, builds upward in order to create open spaces. By stacking people's dwellings, the designer gives the city monumental proportions and a parklike feeling.

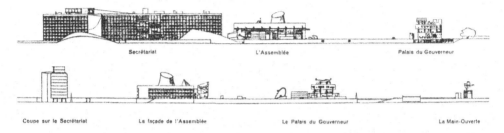

I've been to Chandigarh and I liked it. I liked the High Court best.

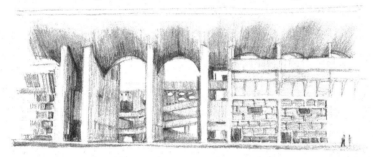

It is grand without being tall, symmetrical, or shiny. It has big airy internal spaces, sheltered by an overarching roof. It has thick concrete walls perforated by an irregular pattern of sunshades. It rewards you with its sense of shadiness and openness in a hot climate, and its unpredictability. You can never guess what you'll see when you look up.

I don't think I'd mind living in Chandigarh, but that may be what's wrong with it. Critics[3] note that Western-style kitchens ignored Punjabi cooking methods. Vast open spaces make it hard to get around on foot. As in Brasilia, the sameness of the architecture gets oppressive.

[3] Brent C. Brolin, *The Failure of Modern Architecture*. New York: Van Nostrand Reinhold Company, 1976. Chapter IV, pp. 88–103.

Shops are confined to commercial strips. But contrary to Le Corbusier's plan, shops of the same kind have bunched up, the way car dealers do in American cities. Since your own neighborhood may not supply what you need, itinerant vendors set up in the park-like margins.

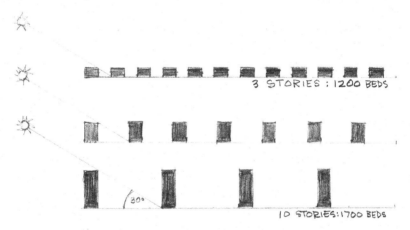

These are not very damning criticisms. Cities are rarely built from scratch anyway. A total makeover is a fantasy.

A better example of design fallibility is urban renewal. In Harlem, in the Chicago slums, in a ring around Paris, and to a greater or lesser extent in most cities, housing projects went up. They were towers surrounded by open space, just as Le Corbusier and Walter Gropius decreed. Gropius arrived at an optimal height for developments—six stories—that balanced efficient land use with direct sunlight and a human scale.

3 STORIES : 1200 BEDS

30°

10 STORIES : 1700 BEDS

These apartment towers have turned into combat zones, and are now being demolished, despite the fact that they have rational layouts, up-to-date wiring and plumbing, a reasonable amount of space per person, and a fringe of open space.

Jane Jacobs, writing in 1961, put her finger on what is wrong with these artificial communities.[4] In traditional urban neighborhoods, a row of street-level doors interspersed with shops gave better access to services, less of a sense of confinement, and most of all a common neighborly experience. By contrast, hallways and elevators in a high-rise funnel everybody through the same depopulated combat zone.

Social design takes away people's power to improvise. The old way allowed cities to grow and adapt by acts of individual initiative. Jacobs even endorsed out-of-scale urban monuments, because people need landmarks to orient themselves.

Starting in the 1970s, urban planners tried to atone for their failings by building row houses and renovating old ones. But urban design's bad record, plus the public's loss of appetite for civic improvements, have given the whole exercise a bad odor. Urban renewal almost always warehoused poor people in out-of-the-way places in order to return downtowns to the middle class. Now Mike Davis observes that the middle class has abandoned most downtowns for a ring around the inner city.[5]

Urban renewal sounded like a good idea. Designers said to themselves, "We can build a better chair. Why not a better city?" The answer turned out to be that

a. they aren't smart enough, and

b. getting enough money to improve poor people's lot would require a substantial redistribution of this country's wealth. That would be a political triumph, not an act of design.

There are other examples, closer to hand, of design run amok—that is, the tendency to design everything in sight. Departments stores are clean, bright, and uniformly cheerful. The lighting is effective, the colors are coordinated.

But no one would want to live in a department store, or a Denny's or even in Disneyland. Everyone likes a degree of disorder and personal caprice in his or her own surroundings.

[4] Jane Jacobs, *The Death and Life of Great American Cities*. New York: Modern Library, 1993.

[5] Mike Davis, "Beyond Blade Runner: Urban Control, the Ecology of Fear," Westfield, NJ, Open Magazine pamphlet series no. 23, December 1992. For other urban pathologies see *City of Quartz, Excavating the Future in Los Angeles*. London and New York: Verso, 1990.

Charles Eames was particularly wary of design megalomania. He started out as an architect, turned to designing furniture, and ended up specializing in film and exhibit design.

His film about his house is not an architectural study. It shows how big windows bring the natural setting inside and illuminate the vast array of things he and his wife Ray collected, from flowers to dolls to kites. The purpose of all his films is to open our eyes.

Eames followed the reforming impulse of modern design to its most humane possible conclusion. He got tired of designing things for

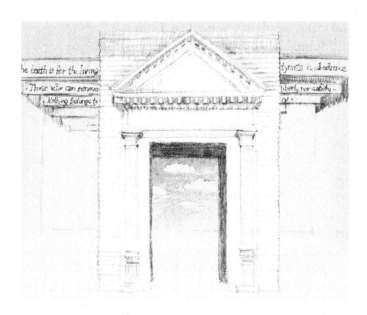

people to buy. He ended up using his design skills to teach. If I can design a better chair, why not a better way to teach mathematics? To show that a mobius strip has one continuous side, Eames ran a model train around it.

His firm did a thoroughgoing study for a National Aquarium. He did highly ambitious exhibits on folk art (in San Antonio), math and computers (sponsored by IBM), America's early contacts with Japan (sponsored by the U.S. Information Agency), and Jefferson and Franklin (also sponsored by the U.S.I.A.).

He believed that clever illustrations can explain complex ideas better than words. He tested this strategy on math, science and history.

But he always resisted oversimplification, and his exhibits are crammed with words.

A People's Car

Modernists expected people to like what's good for them. In 1936, a Depression year, the Consumers Union was formed. Conceived as a service to organized labor, it helped consumers get the most for their money, avoid unsafe products and boycott unfair employers. To preclude any corporate influence, its magazine, *Consumer Reports*, refused to accept advertising and wouldn't let advertisers cite its endorsements.

It tested and compared foods, household appliances and cars, applying solid functional standards to buying decisions that had always been influenced by advertising, custom, and whim. Resolutely indifferent to a product's looks, the Consumers Union tested nutritional content, durability, and performance.

Long before Congress created a National Product Safety Commission, the Consumers Union ferreted out safety hazards. It studied the health effects of cigarettes, detected fallout in American milk from nuclear tests and blew the whistle on dangerous toys.

In 1950, postwar prosperity multiplied its membership by four. Big business had never liked *Consumer Reports*. Now *Reader's Digest* and *Good Housekeeping* tarred it as left wing. It even showed up on the House

Un-American Activities Committee's list of subversive organizations. Consumers Union's dedication to real value as opposed to surface appeal is a perfect expression of the functionalist creed.

Consumer Reports has been telling us for years that Japanese cars are better than American ones. The Toyota Corolla needs fewer repairs than any other car, and offers the best performance and carrying capacity for its price. Why aren't we all driving Corollas? More to the point, why haven't *I* bought one? Would I tolerate shoddy merchandise just to avoid driving a car that looks so dull?

People who are troubled by this question also wonder why Detroit hasn't learned to make Corolla-like cars. Why aren't Detroit cars built to last? And why can't they be better looking? Would it cost more to make a Ford look like a Porsche? After World War II, social critics tried to answer these questions. Americans were agitated about the deception and wasteful expense of advertising. Vance Packard wrote best-selling books called *The Hidden Persuaders*, *The Status Seekers* and *The Waste Makers*.

The Big Three American car makers were an oligopoly. By implicit agreement, they made cars that had to be replaced every three years. Annual styling changes also brought buyers back to the showroom. Horsepower went up each year, though sane drivers have no use for 200+ horsepower engines.

All this was anathema to modernists, who believed that a truly beautiful car would have no styling—its looks would simply flow from function. It would not change every year. So it could be cheap. The car problem is at the center of a New Left economic tract, *Monopoly Capital*, written by Paul Baran and Paul Sweezy in 1966.

Baran and Sweezy figured that annual retooling accounted for 25 percent of a car's price. Subtracting the costs of superfluous styling, the automakers' and dealers' profits, and the gasoline costs from unneeded horsepower, they concluded that a Detroit car costs four times what a socialist car would.

I found this argument convincing. So did a lot of people. For a while England imported Russian Moskvas in the hope they would be like farm tractors—graceless, but cheap and indestructible. In the U.S. there was a brief vogue for Checker Cabs as family sedans. Checkers were heavy cars with big doors, made to serve as taxis.

The desire for a rational car—cheap, beautiful and ever-lasting—was a characteristic modernist wish. When I was growing up, the smart money was on Europe, including movies and philosophy as well as cars. Volkswagens, Saabs and Volvos came close to fulfilling Baran and Sweezy's prescription.

But socialist cars never panned out. Production quotas and lack of competition rewarded Soviet carmakers for building clunkers. The Moskva, and later the Yugo, failed in Western markets, and the East German Trabant died with East Germany. The Soviet Union ended up buying Fiat factories from Italy.

MOCKBA*

Even without world revolution, cars have gotten better. Environmental fears forced governments to demand better fuel mileage and less pollution. Market forces—specifically, competition from Japan—killed annual model changes and improved performance. Detroit cars still don't last, but Japanese cars go 200,000 miles.

Now that there is real competition, it is also clear that styling has genuine market value. It's not just the car makers' way of hiding defects, as Baran and Sweezy thought. People will pay extra for looks. And they like novelty. History answered the questions at the head of this chapter.

1. Why are Detroit cars lemons? Why aren't they built to last?
Because there are people who prefer flash to durability. They could buy a Toyota, but they prefer a Buick. General Motors does, in fact, make Toyota Corollas and sells them as "Geo Prizms." The market is very limited. Contrary to Bauhaus hopes, people don't necessarily like what's good for them.

2. Why aren't they better looking? Couldn't a Ford look like a Porsche?
It's a matter of taste. A lot of people like Fords.

Once in a long time a car appears which sells on looks alone. The Dodge Neon, the Mazda Miata and the new Volkswagen beetle are examples. The Chrysler PT Cruiser is the rare "concept car" which made it into mass production. Harking back to '50s hot rods, it seems to appeal to matrons still dreaming of Fonzie.

The Mini-Cooper is another nostalgic hit. Except for the Miata, none of these cars owes its success to "good design." Designers buy BMWs, Mercedes, Porsches and Alfa Romeos.

The Cult of Creativity

When the modern movement hit its peak in the 1960s, successful designers became seers whose faith in intuition discouraged critical analysis and research.

The Emperor of Design Megalomania was our old friend Buckminster Fuller. He knew he was right because the big guns ignored him. This delusion could be called the Tucker Complex.

Director Francis Ford Coppola made a film called "Tucker" about a guy who tried to introduce a better car and was crushed by the Big Three. They maintained demand for their mediocre products by elbowing out newcomers. Tucker's utter failure proves that he was on to a good thing.

Although it's true that American cars have always been inferior, nobody imagines that Tucker's or Fuller's ideas are the cure. There is now healthy competition between car-making countries. Governments have forced automakers to make safer cars that pollute less and save energy. They don't look like Fuller's Dymaxion Car. Lightweight three-wheeled cars were built in Europe after the war, but only as a cheap substitute for real cars.

Tucker's horizontally opposed cylinders and steerable headlight haven't caught on either. I don't know why, but I am satisfied there is a reason, because I think that in the world of engineering, good ideas eventually win out. Galileo suffered for insisting on the truth. Tucker just suffered.

Fuller nursed a Tucker Complex because he was not an engineer, or an architect or an economist. He flattered his audiences by putting down such experts. A lot

of people liked Fuller because he applauded their ignorance. He pushed common sense as a substitute for learning.

Fuller believed that a big, simple and regular system underlies the infinite variety we observe. Complexity is an illusion. He pushed domes when the world needed, and was building, skyscrapers. Buckminster Fuller's schemes included aluminum house kits, the three-wheeled car, a molded one-piece metal bathroom . . . all promising to do more work with less material. In the long run, none of these were successful.

Fuller was confident that technology could solve all our problems. Only inertia was holding us back. He used to say that if the earth's resources were sensibly deployed, there would be no need for politics. The promise of design is that everything can be fixed up perfectly. We will lie on our sides in a new Eden. In Eden there is no conflict. You already have everything you could ever want. Less is more.

Although Fuller helped popularize the idea that we have a common stake in the planet earth, his faith in technology made him anything but an environmentalist. One of his proposals was a weather proof dome over Manhattan.

He lived in the future, in the dream of design. He ended his career as a spokesman for Wernher Erhard's expensive self-improvement seminars. Erhard forbade his customers to go the bathroom until they grasped "it"—the insight that generosity is foreign to our natures. Fuller and Erhard were both salesmen, pushing shallow panaceas that could be mastered in a single evening.

Because they are clever, designers sometimes overreach. Almost anything can be stated as a design problem ("How can the human race eliminate its genetic defects?" "How can we reduce the cost of educa-tion?"). But complex social questions belong in the hands of voters and legislators.

Tyrants and salesmen, from the pharaohs to Walt Disney, have shared a lively interest in design. Dic-tators like to impose a new and uniform look on their minions. Design brings theater into the real world, promises to create a new reality, a visual harmony: to sweep up the mess.

Having issued all these warnings, I will now admit that design's popular, accessible character is its chief attraction. Everyone *is* entitled to an opinion. And people care about how things look. Martha Stewart's popularity confirms that.

Buckminster Fuller asked college students to wrap their minds around the big design issues. I urge my readers to do the same. Experts or not, we can develop a lively critical appreciation of design simply by pursuing questions we are already in the habit of asking: I wonder how that works? Do I like the way it looks? Why?

Part III
Is There Life In the Bauhaus Ideal?

To correct the excesses of modernism, its solemnity and dogmatism, designers have embraced fashion. Flashy and ephemeral are now okay. But the rebound against modernism is losing its momentum, its capacity to inspire original work.

When design's unwarranted pretensions are hacked away, fresh lines of approach should appear. "Principles" are consistent ways of distinguishing good from bad. Can new ones be forged with the heat from modernism's dying fire?

There *are* timeless design principles. It's not solemn Bauhaus theorists alone who believe this. Functional efficacy will always be an important design criterion. Archaeologists, trying to see why the Anasazi traded villages atop Mesa Verde for new dwellings in the cliffs below, pursue functional lines of thought. Was the move made for defensive reasons? To get closer to year-round water sources in the valley floor? To get out of the broiling sun? The Anasazi may have had religious motives, or been pushed by a mad leader. But that side of their experience is closed to us. We are far more interested in signs that they solved problems in a methodical and ingenious way.

Of course, designers want to be more than merely useful. The most impressive Anasazi site is Chaco Canyon. Huge multistoried pueblos stood in rows along the canyon floor. Highways radiated out to satellite cities. Artisans in this twelfth century city traded in seashells from the Pacific and macaw feathers from Central America. Park rangers warn us not to read this urbanism as a high point in Native American culture. But we do tend to equate highly evolved design with civilization. We appreciate Chaco Canyon as we appreciate Blenheim Palace and the Mazda Miata and an Eames chair, for color, material, proportion, scale and complexity—not just usefulness.

Is it wrong to wish that design could be more public-spirited, less mercenary? Do Detroit car designers actually drive Chevrolets?

Engineers will always be functionalists. When we admire bridges, ships and planes, we revive a modernist sentiment. And architect/engineers like Pier Luigi Nervi prove that functionalism does not rule out fancy.

Modern design's moralistic tone was misplaced. Less is not necessarily better. Only the U.S. Army believes in no-holds-barred functionalism—squat metal office furniture on brown linoleum floors stinking of Lysol, in indestructible warehouse-like buildings.

Designers like Charles Eames, Alexander Girard, George Nelson . . . in fact all good modern designers have used their imaginations to find practical ways of giving pleasure.

Architects and designers still produce solutions to functional problems. But current critical practice discourages us from calling sensible ideas "design." Design is now the whimsical add-on, the designer touch. It is the skyscraper shaped like an inverted L, the candy-colored computer, the fifth leg on the dining room chair. There's nothing wrong with mannerism. But it has come to exert its own tyranny, just as primary colors, geometric shapes and bareness did before.

The preceding chapter set out to puncture Bauhaus pretensions—not to bury modernism, but to save it. The final question is, how can the practical insights of modern design be coupled with postmodern lightheartedness?

Rehabilitate Metaphor

A metaphor substitutes one thing for another. It is a useful comparison: "she's a gem." Similar substitutions occur when we make flat pictures of solid things—representation. And when we use words to stand for things and actions.

Modern design, like modern art, tried to purge "stands for" substitutions from visual culture. It addresses the mind directly through the optic nerve—no prologue, no story, no explanation. Modernist painting is not a Nativity scene or a scowling Napoleon. It's a piece of cloth smeared with paint. Not a virtual reality. Just the thing itself.

Modern architects replaced the historicist impulses of 19th century architecture with candor and simplicity. Buildings of the 1960s look like buildings of the 1960s, not like Greek temples or Romanesque churches. Industrial design adopted the same reductionist principles.

Often, however, metaphor—comparison, substitution, historical associations—crept in. There is no functional excuse for this IBM typewriter to be contoured like an egg. Olivetti models were boxy. I think the IBM designer, Eliot Noyes, was evoking an egg's unusual combination of strength and fragility. He says

he was thinking of a smooth stone. It would also be fair to describe these curves as feminine, and to notice that the corners are rounded like a TV screen. All of these metaphors fit.

When Le Corbusier called a house a "machine for living," he was pushing away all the associations that define it as a home—a nest, a hearth, a family history. But why can't a house be both?

Postmodern designers answered Le Corbusier's purism with two battle cries: "contextualize" and "historicize." Don't pretend to be starting from scratch—acknowledge the past. And don't act superior to your neighbors—fit in. You don't have the only answer—put a little ironic distance between yourself and your work.

One way this translated into design was the tongue-in-cheek quotation.

One way it marked consumer tastes was a brief craze for things like fountain pens, windup watches and rotary phones. But no one really wants to return to the past, and postmodern design stars stopped quoting it.

In any case, modernists were not as wedded to sheer originality as people think. Searching for useful analogies was standard practice. Eero Saarinen made a chair like a wine glass.

Charles Eames made one like a potato chip.

Other designers made chairs like bean bags, like hammocks, like baskets, like bowls, like awnings, like inner tubes and baseball mitts.

Nervi's concrete ceilings look like honeycombs. His reinforced concrete roofs look like scallop shells.

Car interiors started out as buggies. They evolved into living rooms furnished with rugs and soft upholstery. Now they have turned into wombs.

How many pure and original designs have there been? This 16th century French chateau has been a model for New York apartment houses and theme park castles. But it, too, is a set of borrowed ideas. Although it is a summer home, it pretends to be a medieval fort.

The moat has become a waist-deep reflecting pool. The corner turrets, which once allowed defenders to rake the walls with fire, are now bay windows. The battlements, where archers once strode, are also nothing more than a window treatment. Since the Crusades, every castle has been to some extent a Disney castle.

Metaphor is not just false pretense. Comparisons spur the imagination. Who could have invented weaving from scratch? The inventor got some hints from nature.

The wheel was not completely original, although it may be the cleverest invention of all time.

The Wright brothers already knew that heavier-than-air flight was possible.

Similarly, the first boats mimicked floating leaves and petals.

Poking a stick into the mud at her feet, the inventor of writing was halfway there. And there were precedents in nature—impressions that served as a record of earlier events.

Painting came first, but once there were windows, paintings went into rect-angular frames.

Most of what we know about engineering comes from our own muscles. We can feel the leverage in our joints. We know how to arrange ourselves for work.

It's not surprising that a lot of useful gadgets look like body parts.

If every form is in some way a quotation, then metaphor is an indissoluble part of design. Philippe Starck made a building in Tokyo that stands like a hooded monk. It's copper green. I confess I'd rather work there than in an architecturally serious building.

If the chair is not evolving towards its pure and perfect form, why not stretch out on a metal tongue?

Learn From the Past

Despite modernists' hopes, design did not lift itself above history. Bauhaus principles did not turn into a universal design kit. Tastes change. Even if modernism had lived up to its own ideals, it would still be a style, a look. Children don't want their parents' furniture (although grandchildren often do).

Does anything last? Well, yes. Functional concerns will always be the first step in the design process. "Form follows function" was first stated by Louis Sullivan, Frank Lloyd Wright's mentor, a man whose Chicago skyscrapers were plastered with leafy ornament. Functional design did not wait for the Bauhaus. Some of the all-time great industrial designs are old.

Stairs—the low-tech way to go up.
Carries people, animals, even
sofas and refrigerators.

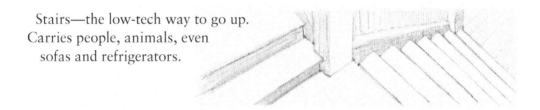

The book—portable, inexpensive, durable high density random access memory.

Glasses. Without them, most
people would have to retire at 45.

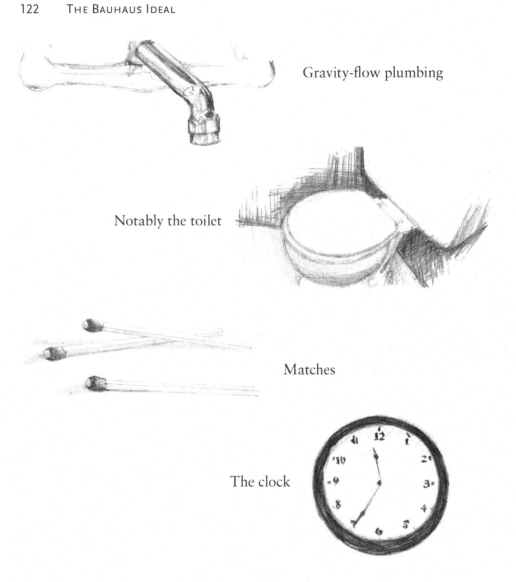

Gravity-flow plumbing

Notably the toilet

Matches

The clock

Many a brilliant marriage of form and function has been made by someone who never heard of the Bauhaus:

The light bulb. The light bulb shape has lasted more than a hundred years.

The steel bookend. Uses the weight of the books, not its own, to keep books in line.

Filing.

The glass thermometer.

The double-edged peeler. This tool works right or left-handed, never needs to be sharpened, and controls the depth of its own cut.

Product designers continue to find simple mechanical solutions to old problems:

Fiskars scissors are a tasteful design which made it into mass production.

The wheeled plastic can can make it much easier to take out the garbage.

Although plastic is hardly new, designers are still finding imaginative uses for it: baby seats, car bumpers and body parts, handcuffs, backup car keys, chip clips, medical tools, prostheses . . .

Don't Let Engineers Take All the Credit

Is better design what we need? Or technical advances like the microchip? Or both? Certainly "inventions" will do more to change the world than "designs." But every new invention calls for inspired design.

Here is a list of modern products which have drastically improved my life. In each case, imaginative design played a role.

The telephone. This model, designed by Henry Dreyfuss, put ear- and mouthpiece up to the user's face and the dial down by the fingers. The gesture of lifting or replacing the handset turns the phone on and off.

In order to replace the fountain pen, the ball point pen had to be both a good writing instrument and cheap enough to throw away when empty.

The first electronic watches had digital displays. Later, people wanted hands. Now you can get both. Although the crystal-controlled timepiece is a technical marvel, people also want it to reflect their personalities.

In Mies van der Rohe's day, the technological marvels were ocean liners, cars and airplanes. Now the leading edge of technology is electronic, not mechanical;

three-dimensional designers feel a little passé. But technology is only one of the forces behind new design. In the 1970s, America was barraged with high-quality Japanese products. In the process, we acquired some Japanese tastes.

Plastic shopping bags, which are barely there, largely replaced paper.

Small cars. Hondas showed the door to gas-guzzling behemoths. Temporarily?

Plastic replaced metal in watches, office equipment and appliance cases. You can now pay thousands of dollars for a plastic box—a computer, a stereo system or a piece of laboratory gear.

Thanks to postwar Japanese design, weight per se is no longer a mark of quality. When it comes to cell phones and CD players, the exact opposite is true. When I was a boy, the most expensive record players came in wooden cabinets. I remember doubting that a pocket-size CD player with hearing-aid earphones could be any good.

In contrast to product design, architecture is Paleolithic. People are still building with stone. Most people's roofs are held up by sawed tree trunks. Cement and mortar are only slightly newer, having been perfected by the Romans. Because of the computer's power to simulate a better world, some theorists argue that architecture's real future is in the virtual realm. We will spend our days in a virtual environment. Mechanisms and structures are the last vestige of the Industrial Revolution. The physical matrix behind the screen will be unworthy of notice.

But what do we stand to gain? Las Vegas roofed the old Fremont Street casino quarter with computer-controlled electronic displays. Since the casino façades were already light shows, the result is a virtual environment. This example suggests that virtual reality is not design creativity, but design tyranny. Stores are already virtual environments, and no one wants to spend all day in one.

Will we happily dispense with the senses of smell, taste and touch? Architecture manipulates spaces, not just surfaces. Product design has always been a tribute to the workings of the human hand.

Having defended three-dimensional designers against the claims of electrical engineers, I will now concede that computers and microchips have changed designers' jobs forever. For one thing, architects and industrial designers now sit in front of computers, not drawing boards. Computers have taken a lot of the tedium out of design. No one has to draw blueprints with a T-square anymore, and no one has to scratch out inked lines to make changes. Drawings can be rescaled automatically. Computer models can be visualized from many angles. Three-dimensional models can be carved by laser control. Ideas are easier to visualize and revise.

A growing proportion of designers make interfaces, not things. They design web sites, making it easier and more pleasant to find out what you want to know. They design desktops, games and icons.

And when it comes to actual things, microchips have changed the ground rules of functional design. When silicon wafers are in charge, function no longer points reliably to form.

Steam locomotives inspired functional designers because they were completely mechanical—all about motion. Fuel shoveled into the firebox heats water in the boiler. The resulting steam pushes a piston. Tie rods transfer the piston's back-and-forth movement to the wheels. Locomotives have fascinated visual artists because their power and energy is dramatically on display.

With a computer, only the fingers move. The workings are invisible. Even dismantled, a computer's appearance tells nothing about what it can do. Ironically, a lot of industrial designers are now employed to make mechanical devices—such as mixers and coffee makers—look like computers.

The typewriter was another elegant machine, a model of functional design. You can take it apart and see how it works.

The moving parts of its successor, the inkjet printer, look like a toy—a plastic box jerking back and forth on a metal track. This toy produces paragraphs, tables and images. How, we can't see. The inkjet printer is a new kind of machine whose precision comes from feedback, not from a finely-machined mechanism. It is less like a clock than like an ant colony.

An ant does not head straight for her destination. Instead, she makes an endless series of course-corrections. She veers off to the left, notices the absence of her sisters' scent and turns back toward the right. When the scent thins out again, she goes left. And so on. That is how a CD player follows the spiral track of music without physical contact.

If a photocell senses that the reflected laser beam is getting brighter than usual, it concludes that the beam is wandering off the trail of indentations, into the shiny margins. So the microchip controller nudges the beam back in the right direction. These corrections happen thousands of times a second. The speed of a microprocessor allows work to be done this sloppy way.

Nothing about a CD player makes visible sense. I have only a vague idea how tiny dents in a mirrored surface turn into music. I can't even see how the machine handles the disc. CD players can be large or small; size is no indication of quality. "Form follows function" loses its meaning in this context.

In spite of all these complications, the Bauhaus ideal is alive and well. Web designers have drawn on the history of print to make web sites more convenient and informative. Product designers have turned technical advances into useful tools. Architects have eagerly adopted new design software and building materials.

Problem-Solving Is Not the Only Design Strategy

Is design a wild dreamlike operation—what Philippe Starck does? Or is it Charles Eames's painstaking search for the best alternative?

It is both.

It is worth remembering that design innovations haven't always solved the problems they were supposed to solve.

When Edison invented the phonograph, he thought it would be used for voice letters. He never imagined people would like its tinny reproduction of music.

The snowmobile was introduced as a recreational vehicle. It has replaced sled dogs in the Arctic.

Roller blades were invented in Japan so ice skaters could practice in the summer. They turned out to work better than roller skates.

Piercing, tattoos and graffiti are examples of folk design. There are many design opportunities which don't manifest themselves as solutions to problems.

Don't Abandon the Dream of Design

The economic importance of virtual design—web sites, software, multimedia—could easily make architects and designers feel obsolete. In fact, three-dimensional design as practiced at the Bauhaus is still a going concern.

Architects have plenty to do. Although few clients want, or can afford, originality, every new building has the potential to be brilliant. The architectural profession as a whole also faces challenges:

1. Mass-produced home kits that anyone would want.

2. Energy-efficient and environmentally thrifty buildings.

3. Fireproof, earthquake-proof, collision-proof structures.

4. Buildings that will still look good at age thirty. "Simple" does not necessarily mean classic. In the '60s and '70s French architects built anonymous glass-walled college campuses and housing projects that have turned into bleak, graffiti-ridden hulks.

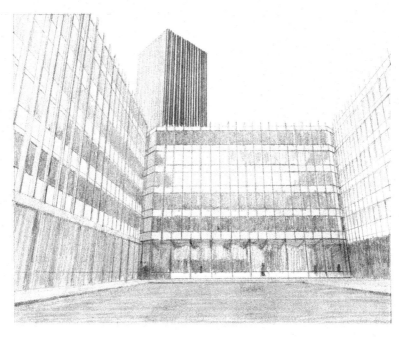

But an architect's distinctive handwriting may not hold up any better. The design competition for the World Trade Center site asked for buildings with symbolic meaning. Daniel Libeskind's winning scheme is topped by a 1776-foot cathedral spire.

It may have been the best entry, but it also reminds us that buildings can "speak" only in a constricted, halting voice. Maya Lin's Vietnam Memorial is the opposite of symbolic. It is a place for mourning, not a tomb or a flag or a statue.

There are no reliable do's and don'ts for a timeless, perennial architecture.

My favorite buildings from the heyday of modernism include Frank Lloyd Wright's Taliesin West (shown here), the Pompidou Center in Paris, Le Corbusier's Carpenter Center in Cambridge, Mass., and the Sydney Opera House (p. 23)—four designs which have practically nothing in common except a big budget.

The Bauhaus tradition, in opposing itself to barefisted market economics, also poses design challenges that only voters can solve:

Preserving open space in places like New Jersey, where developments are filling the map.

Housing everybody.

In the area of product design, there are plenty of tangible problems microchips won't solve:

Unbreakable glass.

Puncture-proof tires.

An affordable replacement for utility poles and overhead wiring.

Palatable airline meals.

The Third World is waiting for good roads, cheap housing and medical care, running water and an energy source to replace firewood.

It's interesting to remember the product design challenges which were on the cover of *Popular Mechanics* in my youth.

Correcting typewriters
Instant photography
Wash-and-wear fabrics
Disposable paper clothing
Contact lenses
Freeze-dried and irradiated foods
Fiberglass boats
Frost-free refrigerators
Home dishwashing machines
Garbage disposals and compacters
Amphibious cars

A few, such as fiberglass boats, have been more important than one might have expected. Others, such as the correcting typewriter, have lost all meaning.

Many design challenges of my childhood still look just as daunting as they did then.

Robots that do housework.

 Colonizing other planets.

Preventing traffic accidents by automating personal transport.

 Eliminating the radiation hazards from nuclear energy.

Batteries light enough to make electricity a practical substitute for gasoline.

 A bicycle/rollerblade helmet that does not look like a brain tumor.

Commuting by air. Le Corbusier's model city of 1922 had a landing pad for "air taxis." There have been several prototype car/airplanes. One of them towed its folded wings in a trailer. Like a lot of good ideas, air commuting never materialized.

The main problem is that you need two airports. Getting to and from the airports takes more time than you save by flying. Even helicopters need a rooftop landing pad. It isn't practical for the 1500 tenants of the Met Life building to converge there at 9 A.M. They should be able to fly in through their office windows.

It strikes me that computer control ought to make flapping flight possible. Could a computer sense the kind of balance corrections a tightrope walker makes and translate them into instructions to the wings? That's how computers keep tailless Stealth airplanes aloft.

Leonardo dreamed of strap-on wings. The first gliders looked like his sketches. Scuba gear enabled us to swim like fish. Sooner or later we will fly like birds.

We could hover while waiting for traffic to clear. We could behave the way

people do on a crowded sidewalk, constantly adjusting our stride and balance to avoid collisions. Or like the hordes of bicyclists who navigate intersections in China without traffic signals.

Although they fly very fast and often seem to tangle, moths never crash and burn. They have big wings in comparison to their body size; a better model might be the house fly. On the other hand, flies are noisy. Maybe there's a happy medium.

We live in a designed environment. Like the Bauhaus pioneers in 1919, I think it's time to raise our sights again, to recognize design as a defining element of our culture and to applaud designers, who help us do more than we ever dreamed we could.

Annotated Bibliography

This bibliography is the opposite of encyclopedic. It lists only books that strike me as especially interesting, for better or worse.

Design History

Curtis, William J. R. *Modern Architecture since 1900.* London: Phaidon, 1996. 736 pages. A beautifully illustrated survey. Although it acknowledges postmodern architecture, the book is really about the modern. Gives special weight to Le Corbusier, who deserves it.

Forty, Adrian. *Objects of Desire: Design and Society 1750–1980.* London: Thames & Hudson, 1986. Forty's historical examples show that industrial design has always had more to do with selling products than creating ideal forms. His best chapter is on kitchen design. British kitchens switched from dark woodwork and cast iron equipment to white enamel and polished metal when doctors realized that disease is spread by germs, not poor ventilation.

Meikle, Jeffrey L. *Twentieth Century Limited: Industrial Design in America, 1925–1939.* Philadelphia: Temple University Press, 1979. Meikle chronicles the American stars of this period—Norman Bel Geddes, Raymond Loewy and Henry Dreyfuss. A historian, he shows how the apparent functionalism of shiny, streamlined design derives more from French Art Deco than from engineering.

Rasmussen, Steen Eiler. *Experiencing Architecture.* Cambridge: MIT Press, 1959. 245 pages. A charming first-person essay by a practicing architect about buildings he likes and why. It demonstrates that creativity in architecture comes from detailed observation and reflection, not from any set of prescriptions. Rasmussen enlists all the senses and the history of Western civilization in his catalogue of the architect's resources.

Rybczynski, Witold. *Home, A Short History of an Idea.* New York: Viking, 1986. An anecdotal history of "comfort" in Western history. This is Siegfried Giedion's *Mechanization Takes Command* in digestible form. Starts in the Middle Ages with one-room dwellings that lack plumbing or kitchens, and ends up in the present. Informative on design genealogy: for example Chippendale furniture, now remembered as a signature style, was a catalogue of Classical, earlier European and Chinese forms. Cabinetmaker George Hepplewhite, one of the first craftsman who might be called a "designer," is quoted on the dual imperatives of design: "To unite elegance and utility, and blend the useful with the agreeable, has ever been considered a difficult, but an honourable task" (p. 120).

www.greatbuildings.com. This site has a nicely-indexed trove of standard photographs of famous buildings, including old ones. It offers scanty information, however, and does not make a serious effort to compile useful links.

About the Bauhaus

Bayer, Herbert, with Walter and Ise Gropius. *Bauhaus 1919–1928*. New York: Museum of Modern Art, 1938. 224 pages, heavily illustrated with photos and drawings. Catalogue for a big show at New York's Museum of Modern Art mounted five years after Nazis closed the Bauhaus. Gropius was by then teaching at the Harvard Graduate School of Design, Albers at Black Mountain College, and Herbert Bayer was a New York graphic designer. Gropius and MOMA director Alfred Barr share an exalted, visionary tone. Modern design, like modern art, is a cause that will eventually triumph over the Victorians.

Droste, Magdalena. *Bauhaus 1919–1933*. Translated by Karen Williams, Berlin, Taschen, 1993. 256 pages, lavishly illustrated. Large format. A concise, reasonably-priced large-format history produced by the Bauhaus Archive in Berlin. The beautiful illustrations include photos of Bauhaus personalities and activities, plus examples of student and teacher work.

Fiedler, Jeannine, and Peter Feierabend, eds. *Bauhaus*. Cologne: Könemann, 1999 (translated from German). 640 pages, lavishly illustrated. Large format. The all-time illustrated compendium on the Bauhaus. Illustrations are beautifully reproduced, old photos cleaned up and enhanced. The text is a collection of essays by German design historians. As experts, they are less interested in perpetuating the myth than in debunking it. So we learn about Bauhaus alumni and the Nazis, Bauhaus alumni and the East Germans, gender inequality at the Bauhaus, internal conflict, institutional dead-ends and self-contradictions. Some categories of Bauhaus work that have been insufficiently recognized are brought out here, especially photography. A stunning book.

Gropius, Walter. *The New Architecture and the Bauhaus*. Cambridge: M.I.T. Press, 1965. In this solemn little book, originally published in 1936, Gropius spells out the rationale for modern architecture: 1. "honesty of thought and feeling"—getting rid of ornament and historical convention; 2. technical sophistication—lighter buildings exploit engineering advances and suit a technological age; 3. sunlight and fresh air—lighter buildings bring the healthy outdoors inside; 4. egalitarianism—the "new architecture" abolishes high/low distinctions that used to link taste with social class. Gropius explains that the next big challenge is town planning.

Lupton, Ellen, and J. Abbott Miller, eds. *The ABC's of* ▲ ■ ●: *The Bauhaus and Design Theory*. New York: Princeton Architectural Press, 1993. 64 pages. Originally an exhibit catalogue, this thin collection of essays puts Bauhaus design principles into a historical context. Examples include the grid, regular geometric forms, children's art, Gestalt psychology, language/vision correspondences, sans-serif typography and color theory. More suggestive than definitive.

Schlemmer, Oskar, with Laszlo Moholy-Nagy and Farkas Molnár. *The Theater of the Bauhaus*. Translated by Arthur S. Wensinger, edited by Walter Gropius and Arthur

S. Wensinger. Baltimore: Johns Hopkins University Press, 1996. Many photographs. Translation of a 1924 Bauhaus publication with fresh material added. Oskar Schlemmer, founder of the Bauhaus theater program, defines theater as "form and color in motion." He wants to replace characters and stories with something more generalized and potentially more profound. Acknowledging that a completely mechanized presentation might be even better, Schlemmer shows how costume, dance, music and pantomime enable human performers to transcend tired theatrical conventions.

His fellow teacher Moholy-Nagy elaborates, proposing "a theater of totality." Like mankind itself, it cannot be reduced to a single tidy meaning. Space, light and color should play a far more active role than we know from the present "peep-show stage" (p. 68).

Creating a Rationale for Modern Design

Kepes, Gyorgy. *The Language of Vision*. Chicago: Paul Theobald, 1944. Kepes, born in Hungary, himself a painter and graphic designer, studied under Moholy-Nagy in Chicago. He edited the MIT Press *Vision + Value* series which nestles unread on many a design student's bookshelf. From the introduction: "Today we experience chaos . . . our common life has lost its coherency. . . The collective efforts of scientists have given us a richer and safer life in the biological and physical realms: we must meet them in the socio-economic and psychological realms" (pp. 12–13). He argues that "the language of vision, optical communication" is the human lingua franca, and urges us to refine our perceptions in order to combat formlessness. The book relates cognitive psychology to the means used by artists and designers, including Herbert Bayer, Kepes himself, Paul Rand, El Lissitsky, Cassandre and others.

Mumford, Lewis. *The City in History*. New York: Harcourt Brace, 1961. 657 pages. A sane, liberal American vision of the city as a soluble problem. Throughout Mumford's history, from Roman times to the present, anti-democratic governments and raw market forces lead to "megalopolis." The antidote is urban planning. Positive examples include classical Athens, Pompeii, Venice, Renaissance Rome and Florence, L'Enfant's Washington, Ebenezer Howard's Garden Cities. Like Siegfried Giedion's books, this one is far too long to be readable, but uses its stupendous page count to buttress a rather simple point.

Nelson, George. *Problems of Design*. New York: Whitney Library of Design, 1957. George Nelson was a modern furniture designer whose work is still available from Herman Miller. This set of essays is an interesting reminder of the postwar American faith in corporations (examples: IBM, Polaroid) and their ability to deliver technological progress. Nelson consistently endorses systems, networks, structures that will make sense of a formless mass of detail. Like other theorists of the modern, he asks designers to "find meaning within the framework of a society which is going through a transformation of extraordinary dimensions, a change so drastic that it tends to assume more and more the appearance of a crack-up; physical, economic, moral and aesthetic" (p. 60). He would like to think of the industrial designer as an artist, but recognizes that the individual will is constrained by "the organization:" "A superior individual in the Renaissance could assemble in his own head all the significant information of his time. A superior individual in the 20th century could not possibly begin to do this. His role

in this respect has had to be taken over by the organization" (p. 77). He delivers a lively defense of urban renewal, though all of his examples come from a mythical Middle Western town: "Blight occurs in cities at almost exactly the places where building should be cleared out anyway to make room for sun, air, and automobile" (p. 168).

Read, Herbert. *Art and Industry.* London: Faber and Faber Ltd., 1966 (Fifth edition of a book originally published in 1932). Sir Herbert Read was a public-spirited design critic and educator. From the introduction: "A technological civilization has come to stay and what is now urgent is to prevent it destroying itself from lack of a controlling vision" (p. 15). Read wants to reconcile Ruskin and William Morris with mass-production. The key word is "art." Mass-produced things can obey the laws of "abstract art" (as opposed to painting and sculpture—"humanist art"). Designers should now be regarded as artists, and asked to imbue mass-produced goods with the aesthetic quality of handmade crafts. As at the Bauhaus, they should train as craftsmen. Read is a categorizer, listing three categories of response to art (formal appeal, emotional or intellectual expression, intuitive or subconscious), three properties of "form" (material, working, purpose or function). He goes through the various materials used in mass production, from clay to leather, and to point out their "essential" nature and condemn "imitative" uses (e.g. wood with a fluid form, glass with a geometrical form).

Practicing Modern Design

Boesiger, Willy, and Hans Girsberger, eds. *Le Corbusier 1910–65.* Basel: Birkhauser, 1999. The Bauhaus can't take credit for Le Corbusier. Nevertheless he was probably the best modern architect. His praise of Euclidean forms is often quoted: "Architecture is the informed, correct and magnificent play of volumes assembled under the light. Our eyes are made to see forms under light; shadows and highlights reveal the forms; cubes, cones, spheres, cylinders or pyramids are the great primary forms which light reveals best; their image is precise and tangible, without ambiguity. That's why they are the beautiful forms, the most beautiful forms. Everyone agrees on that, the child, the savage and the metaphysician. It is the foundation of all the plastic arts . . ." (from *Towards an Architecture*).

Le Corbusier's work ranges from sublime to grotesque. For example, he kept proposing colonized Algiers as the site of a futuristic urban redesign. But the sublime predominates.

Jodidio, Philip. *Tadao Ando.* Köln: Taschen, 1997. Looking at Tadao Ando's work is a good test of one's ability to judge and appreciate architecture. Ando's name is not a household word and he played no part in the historical origins of modern design. But his concrete buildings have the kind of austere beauty that the Bauhaus aspired to.

Neuhart, John and Marilyn, with Ray Eames. *Eames Design: the Office of Charles and Ray Eames, 1941–1978.* New York: Harry Abrams, 1989. 456 pages, mostly illustrations. Large format. Thorough, responsible documentation of Eames design projects from the earliest molded plywood experiments to the late exhibition and multimedia designs. A beautiful book.

Papenek, Victor. *Design for the Real World; Human Ecology and Social Change* (second edition). Chicago: Academy Chicago Publishers, 1984. A lively, irritating New Left tract

arguing that corporate America discourages truly functional design. By the author of *How Things Don't Work* (1977). A typical statement: "The bathtub doesn't work. Neither does the shower. Nor does the toilet, or the washbasin. Contrary to popular myth, the room is unsanitary, dangerous, badly thought out, energy wasteful and a health hazard" (p. 3). Another: "Merely by eliminating the social and moral irresponsibility still prevalent in all too many design offices and schools, the needs of the neglected southern half of the world could be met" (p. 342). Opposing "true needs" to "false values" inculcated by advertising, Papanek expresses an anti-market creed that is less convincing now that the planned economies of Russia and China have crashed. Papanek and his students have many ecologically sound, socially responsible ideas that never made it into production. I agree with him that design and politics are closely intertwined. But more modesty would be in order. Poor people need money, not design.

Petroski, Henry. *The Evolution of Useful Things.* New York: Alfred A. Knopf, 1993. Petroski is head of the civil engineering department at Duke. This book is a series of design case histories, from straight pins to Post-It Notes. A little prolix—light reading. He stresses the fallibility of engineers and designers, declaring that "form follows failure." That is, corrected mistakes usually have more forward momentum than original inventions.

Smith, Michael Pomeroy. *Sydney Opera House: How It Was Built and Why It Is So.* Sydney: Michael Pomeroy Smith, 1984. 64 pages. Large format. Illustrated with drawings by the author. This ingenious book makes it clear how difficult life becomes when an architect departs from tried-and-true post and lintel construction. Structural engineers labored for six years on a structure to support the Opera House's sails, changing the building's profile. An important goal was to fabricate the building from uniform, mass-producible elements. It was only partially realized; hundreds of pieces of glass, for example, had to be individually cut to their own irregular shapes. It took ten years to work out the window support structure. Halfway through this process the architect resigned in disgust. The expense of all this innovation must have been stratospheric.

Establishing a Modern Design Canon

Drexler, Arthur. *Ludwig Mies van der Rohe.* New York: Braziller, 1960. 126 pages. From the "Masters of World Architecture" series. A good example of the defocusing process whereby "successful" architects become "great" ones. Drexler throws everything he ever learned into exalting his hero: "It may also be said of Mies that he is the architect *par excellence* of civilization, of law and order, of the great metropolis; in the poetic Spenglerian sense he is the architect of the Universal State, striving to preserve and renew old values. His architecture seeks an absolute and unvarying principle, assumed to be independent of the sense through which its manifestations are perceived. Plato would not be ill at ease in the Miesian world of form" (p. 9).

Giedion, Siegfried. *Space, Time and Architecture.* Cambridge: Harvard University Press, 1967. An 897-page book based on lectures Giedion gave at Harvard in 1938-39. Like Hitchcock and Johnson's *International Style*, this book helped to establish a canon in modern architecture and city planning. It has been assigned reading for generations of architecture students. Giedion understands architectural history as a process of evolution

whose forms have derived from the structural means available. Modern architecture, with the most powerful methods and materials, is therefore the best ever.

Giedion wants design to cure the modern spiritual dilemma—compartmentalization, a split between thinking and feeling, arts and science. In his next encyclopedic book, *Mechanization Takes Command* (1946), he shows how mechanization has made life both more comfortable and more anonymous. One means of healing the wounds made by industrialization is urban redevelopment—selective rebuilding of cities to create axes joining significant public places. He praises the clearing out of disorderly neighborhoods, to introduce light, speed, and order, in Rome and Paris in the 18th and 19th centuries. In the last 30 years this idea has been thoroughly debunked.

Hitchcock, Henry-Russell, and Philip Johnson. *The International Style*. New York: Norton, 1995. 269 pages. Reprint of a 1932 catalogue from the New York Museum of Modern Art. To bring Americans up to date the authors toured Europe looking for the best in modern architecture. Intoxicated with its radical newness, the authors tried to explain modern architecture as a set of rules. This makes them sound snobbish and hidebound. But the buildings still look strikingly new and original.

Design and Psychology

Arnheim, Rudolf. *Art and Visual Perception: a Psychology of the Creative Eye (The New Version)*. Berkeley: University of California Press, 1974. 508 pages. A book whose appealing goal is to reconcile the arts (painting and sculpture) with science (cognitive psychology). It has been on college reading lists for decades. Arnheim uses the insights of Gestalt psychology to show how the best art builds on the way we actually perceive things. Chapters include "Balance," "Shape," " Form," "Space," "Light," "Color," and "Dynamics." The final and shortest chapter is called "Expression." As a dyed-in-the-wool formalist Arnheim barely concedes that paintings can tell stories or reiterate familiar (for example Biblical) themes. To the end he stresses the expressive qualities of pure form. This book is packed with brilliant observations. Unfortunately, it is a 500 page list, easy to put down.

Norman, Donald. *The Design of Everyday Things*. New York: Currency/Doubleday, 1988. 257 pages. This bestseller takes it for granted that industrial designers are fools who persistently overlook the most obvious patterns of human perception and behavior: "The result is a world filled with frustration, with objects that cannot be understood, with devices that lead to error. This book is an attempt to change things" (p. 2). Norman gives many interesting case histories. His disgusted tone recalls Buckminster Fuller's, and has the same kind of appeal. Although the book presents itself as a skeptical take on design, it actually delivers the Bauhaus ideal at full strength—the faith that really clever design (just around the corner) will raise and transfigure human life.

Demystifying Modern Design

Banham, Reyner. *Theory and Design in the First Machine Age*. Cambridge: MIT Press, 1986 (first published in 1960). Traces the evolving critical rationale for modern design at the beginning of the 20th century. Banham tells what European architects, teachers and critics said during the transition from Beaux Arts to the machine esthetic. He denies

that modernism was a radical break with the past. He cites Le Corbusier's beginnings as a painter to support his general argument that modern architecture is a look, not the rational outcome of functional and economizing strategies. With regard to the Bauhaus he shows there was a smooth continuity between Arts and Crafts and Bauhaus "Elementarism"; the International Style was as timebound and modish as any other style. Banham says modernist buildings tend to be structurally conventional, unlike, say, Buckminster Fuller's daring pylon-hung Dymaxion House. He agrees with Fuller that International Style architects "demonstrated fashion-inoculation without necessity of knowledge of the scientific fundamentals of structural mechanics and chemistry" (p. 326).

Brolin, Brent C. *The Failure of Modern Architecture.* New York: Van Nostrand Reinhold, 1976. A low-key critique of modernist dogma by an architect. His tone is disappointed: the emperor has no clothes. Illuminating case histories include Le Corbusier's new city of Chandigarh.

Dick, Philip K. *Do Androids Dream of Electric Sheep?* New York: Ballantine Books, 1996 (originally published 1968). Science fiction was a bestselling category in the '50s and '60s. Dick's books, all scarily excellent, foresee a world where technology and state power combine to deprive us of all personal autonomy. These fears were shared by many science fiction authors, including George Orwell.

Herdeg, Klaus. *The Decorated Diagram: Harvard Architecture and the Failure of the Bauhaus Legacy.* Cambridge: MIT Press, 1983. 125 pages. A somewhat strident denunciation of modern orthodoxy. The author is an architect and a teacher of architecture.

Holston, James. *The Modernist City: an Anthropological Critique of Brasilia.* Chicago: University of Chicago Press, 1989. Although this book is twice as long as it should be, it is full of interesting ideas and observations. Brasilia reflects Le Corbusier's hope that the city could be a machine to fix the problems of modern society. In Holston's account Brasilia is both a success—a pleasant place to live and work—and a failure—a chilly, exclusive showplace. Designed to level class distinctions, it reinforced them. Lack of a street grid eliminated street life. And so on.

Jacobs, Jane. *The Death and Life of Great American Cities.* New York: Modern Library, 1993. 598 pages. Originally published in 1961. A model of design writing—the book that cut urban renewal down to size. Using anecdotal evidence rather than statistics, Jacobs showed why no amount of design know-how could make housing projects livable. When hundreds share the same front door, it becomes a locked-in meeting place for strangers, some with criminal intent. Unlike her own Greenwich Village neighborhood, big redevelopment projects rob residents of initiative. She wants planners to strengthen residential neighborhoods so that stores and services, plus a network of mutually supportive acquaintances, will give residents the means to improve their own lot.

Postmodern Design

Starck, Philippe. *Starck.* Köln: Taschen, 1996. 336 pages, large format. An important designer must have a lot of ideas, be able to manage a large crew, and see design ideas through into production. Philippe Starck is a big success in all these ways.

Venturi, Robert, with Denise Scott Brown and Steven Izenour. *Learning from Las Vegas: the Forgotten Symbolism of Architectural Form.* Cambridge: MIT Press, 1977. 192 pages. Probably the most overrated book in the history of design writing. The authors decided to glory in vulgarity, not sniff at it. This gesture resonated throughout the design world. But the content is amorphous and unenlightening—a barely edited stack of pages churned out by a Yale design class. The authors make one memorable distinction—between a "duck" (a building with its own distinctive form) and a "decorated shed" (the Vegas norm, a plain box hung with tinsel). The book claims huge casino signs are functional—they catch the eye of speeding motorists. But the Strip is not an expressway. Eyes-only simplemindedness causes Venturi and his crew to miss some of the really intriguing contradictions of Las Vegas—the gambler's love of losing, the historical allusions, the odd commingling of Protestantism and vice, big-time entertainment and Bingo, night and day, indoors and out.

Koolhaas, Rem. *Delirious New York: a Retroactive Manifesto for Manhattan.* New York: Monacelli Press, 1994 (originally published 1978). A chronicle of design excess in turn-of-the-century New York. Coney Island used to be a theme park as elaborate as Disney World. Early Manhattan high-rises made room for circus-theme restaurants and Turkish baths. A strange excursion into history by a busy architect, apparently meant to knock some of the stiffness out of his profession. He has followed up with a study of shopping.